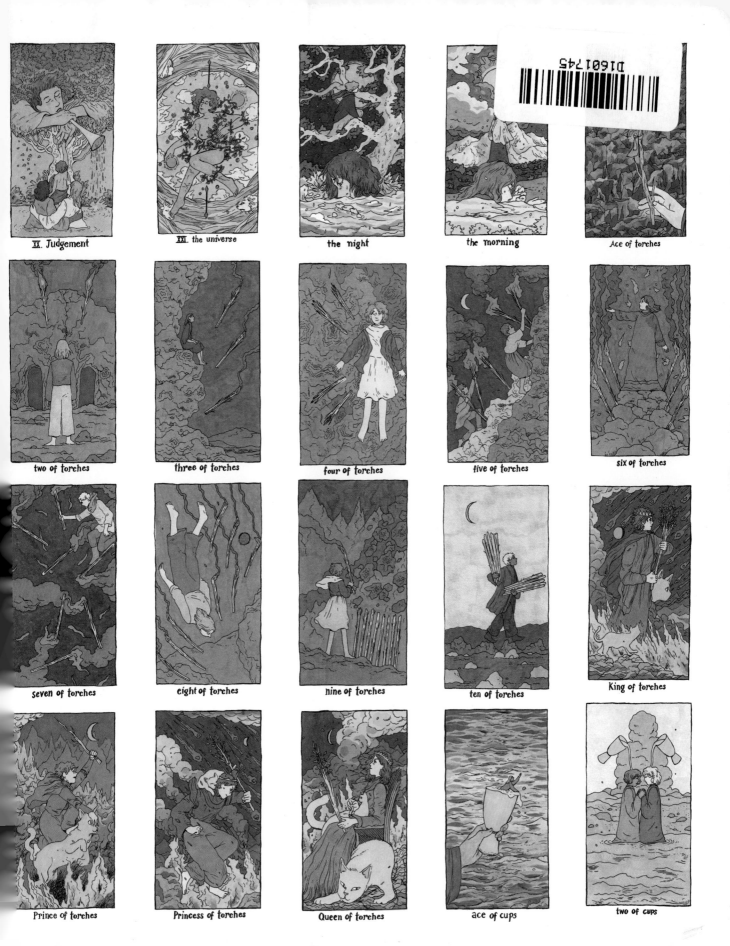

XX. Judgement

XXI. the universe

the night

the morning

Ace of torches

two of torches

three of torches

four of torches

five of torches

six of torches

seven of torches

eight of torches

nine of torches

ten of torches

King of torches

Prince of torches

Princess of torches

Queen of torches

ace of cups

two of cups

STERLING ETHOS
New York

Sterling Ethos is an imprint of Sterling Publishing Co., Inc.

© 2021 Tillie Walden

ISBN 978-1-4549-4329-7

Distributed in Canada by Sterling Publishing Co., Inc.
c/o Canadian Manda Group, 664 Annette Street,
Toronto, Ontario M6S 2C8, Canada

For information about custom editions, special sales, and premium
and corporate purchases, please contact Sterling Special Sales at
800-805-5489 or specialsales@sterlingpublishing.com.

Manufactured in China

2 4 6 8 10 9 7 5 3 1

sterlingpublishing.com

FOREWORD

The act of coloring is one that I have a long relationship with, like we all do. When I was young, coloring was simple and fun, and mostly worry-free. I remember being drawn to teals and pinks. But as I got older and my art became something to make in the 'right' way, rather than something to simply enjoy, my relationship to coloring became strained. I avoided color for a long time, feeling safer in the world of blacks and whites and grays. Drawing was hard enough, why bother with color?

It wasn't until making this tarot deck that I was forced to have a reckoning with color. There was no way around it — the tarot demands color not only because of its history, but because the colors bring the imagery to life. Though I was afraid, I laid out all my markers and my three watercolor sets on the table, and took out the first card in line: Strength.

I had learned through the process of making the cards that a fundamental part of the Tarot is to trust oneself. So I trusted and reached out and chose the colors that felt right. As I colored card after card I surprised myself over and over with which colors I was drawn to. Each card seemed to have an atmosphere of its own that demanded certain shades of blue, red, or green.

I realized that my fear of coloring had been holding me back from the vast world that color presents. Working on the deck not only taught me to be exploratory, it was a respite for me in a busy life. I would wake early, around 6am, and immediately start coloring, still half asleep, my cup of coffee my only witness.

I like to think that the way I colored the cards was what the universe needed of me in that moment. Those yellows, purples, and oranges were the colors of a moment in my life. But now, the cards have a chance at a new life, and for someone else to make their mark on them. If I can leave you with one piece of advice: whatever you color with, lay each color around you, don't let them hide in a box or pencil case. Every color deserves your time.

Tillie Walden

INTRODUCTION

Welcome, dreamer. And welcome to the dream! This coloring book is designed to take you on a journey into the Cosmic Slumber. Along the way, you'll learn more about this deck, the tarot, dream symbolism, and yourself.

Have you ever wondered what secrets your dreams could unlock? What figures populate your dreams, and how they relate to your inner self?

Tarot has always been a tool to gain insight into higher wisdom, and this book acts as a guide for the classic symbolism in the deck. But the Cosmic Slumber goes a little deeper, and a little sideways — so if you're looking for a truly original dreaming experience, you're already holding it in your hands.

HOW TO USE THIS BOOK

This coloring book is part of tarot practice — which is to say, tarot isn't just about readings and spreads. Journaling your experience, researching meanings, and finding new ways to interact with the tarot can take your practice to a higher level and expand your understanding. Ultimately, the more you put into tarot, the more you get out of it.

For decades, people have been coloring tarot cards as a way to immerse themselves in the Fool's journey. So, as you color, really think about each card's specific moment. Think about what the card looks like and how it makes you feel as you color. You might find some new meanings come to light!

In this coloring book, you will find...

✧ A line-art version of **each card** to color in
✧ An exploration of the card's **dreamscape**, **archetypes**, and **symbols**.
✧ Four questions to help you **reflect** on what each card means to you
✧ A beautiful **mandala** inspired by each card for you to color in

This book will take you on a journey through a beautiful, shifting dream. We'll visit many different scenes together, and you'll be invited to think about what each new location means to you. As much as this is about the tarot, really, it's all about you: like a Choose-Your-Own-Adventure story, you are the main character of this book.

Keep an eye out for Tarot Tips that add tidbits of meaning, and think deeply on the Reflections — four questions that invite you to explore what each new dream means to you.

Oh, and as it's a coloring book, color is incredibly important! Each card has a Color Code that tells you which colors appear. This relates back to the palettes on the interior flaps of the cover.

The colors we see in dreams are unlike anything we find in the waking world. Our dreams are vivid, full of shifting hues and painted by emotion. You'll find that some colors in the Cosmic Slumber Tarot are the opposite of what you'd expect, but here's a guide to what they might mean...

✧ **Red** — Power, passion, dawn
✧ **Purple** — Otherworlds, secrets, magic
✧ **Magenta** — Drama, passion, fate
✧ **Yellow** — Inspiration, halos, inner light
✧ **Orange** — Sunlight, daylight, creativity
✧ **Blue** — Peace, tranquility, feeling
✧ **Green** — Nature, hope, new life
✧ **Cream** — Thresholds, boundaries, higher knowledge
✧ **Gray** — Duality, logic, wisdom

As you use this book, why not keep a dream journal? That way, you'll be able to keep track of what really appears in your dreams, and you'll be able to spot any special personal significance for you within the card. After all, the dream is yours and it's whatever you make of it...

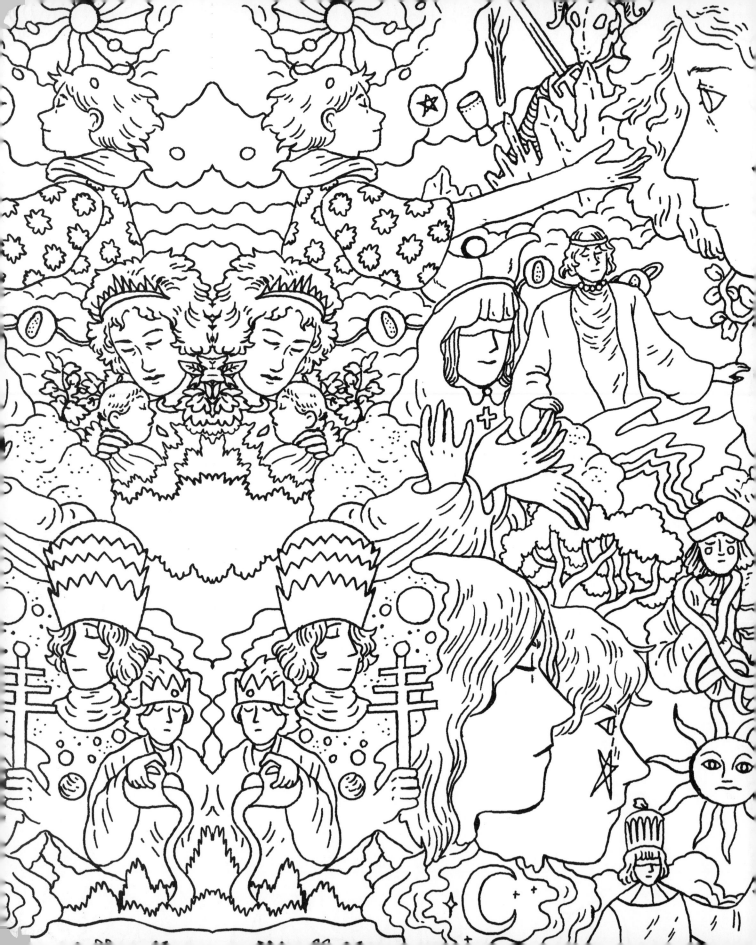

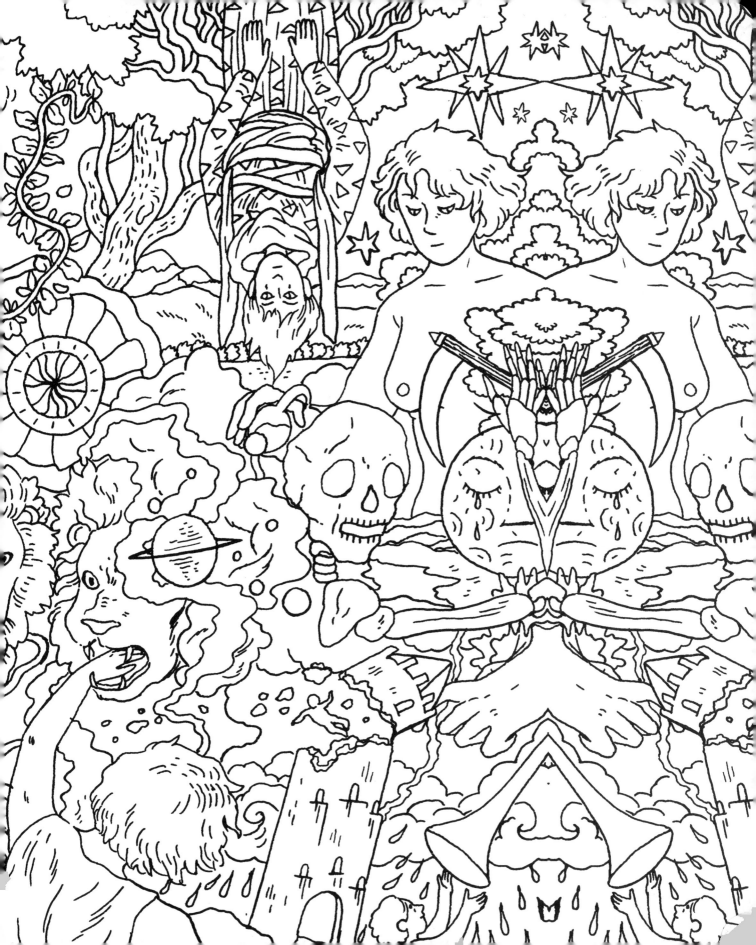

O. the fool

Wandering into slumber, the fool can't see what's ahead of them..but what happens if you're asleep in a dream?

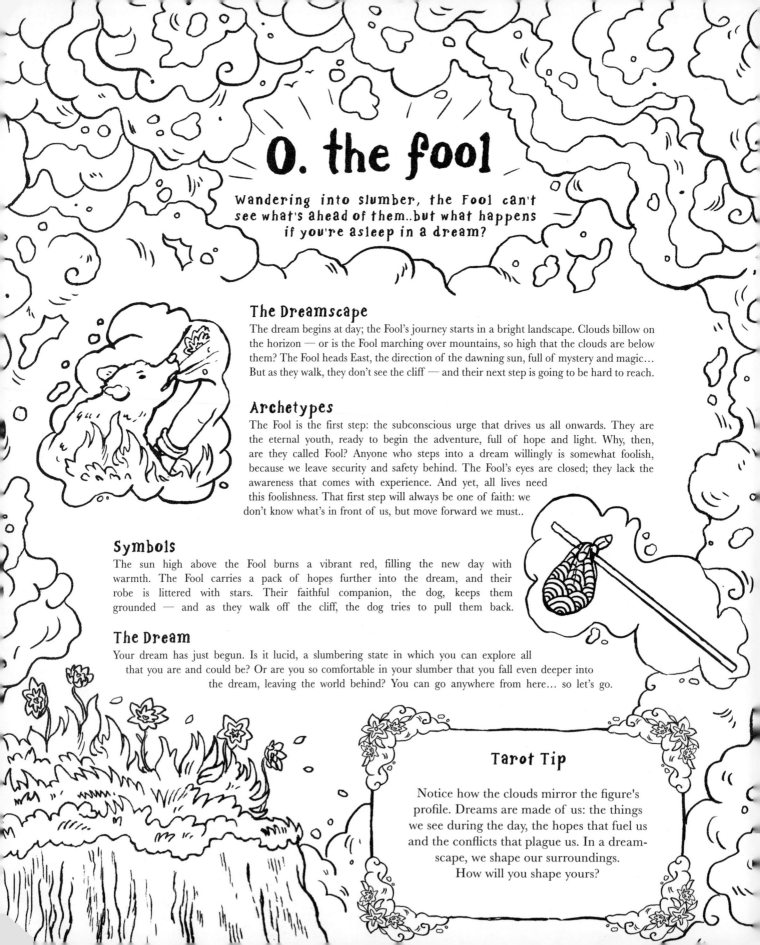

The Dreamscape

The dream begins at day; the Fool's journey starts in a bright landscape. Clouds billow on the horizon — or is the Fool marching over mountains, so high that the clouds are below them? The Fool heads East, the direction of the dawning sun, full of mystery and magic… But as they walk, they don't see the cliff — and their next step is going to be hard to reach.

Archetypes

The Fool is the first step: the subconscious urge that drives us all onwards. They are the eternal youth, ready to begin the adventure, full of hope and light. Why, then, are they called Fool? Anyone who steps into a dream willingly is somewhat foolish, because we leave security and safety behind. The Fool's eyes are closed; they lack the awareness that comes with experience. And yet, all lives need this foolishness. That first step will always be one of faith: we don't know what's in front of us, but move forward we must..

Symbols

The sun high above the Fool burns a vibrant red, filling the new day with warmth. The Fool carries a pack of hopes further into the dream, and their robe is littered with stars. Their faithful companion, the dog, keeps them grounded — and as they walk off the cliff, the dog tries to pull them back.

The Dream

Your dream has just begun. Is it lucid, a slumbering state in which you can explore all that you are and could be? Or are you so comfortable in your slumber that you fall even deeper into the dream, leaving the world behind? You can go anywhere from here… so let's go.

Tarot Tip

Notice how the clouds mirror the figure's profile. Dreams are made of us: the things we see during the day, the hopes that fuel us and the conflicts that plague us. In a dreamscape, we shape our surroundings. How will you shape yours?

COLOR CODE

Magenta, yellow, salmon, purple, blue,
light green, gray, brown, peach.

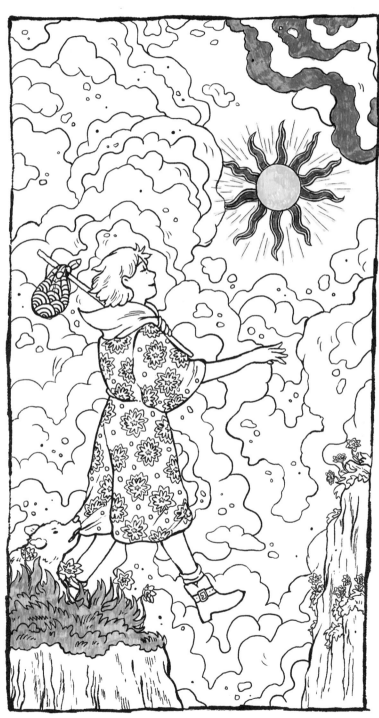

the fool

REFLECTIONS

The Fool reaches forward, already moving through the dream in a different way to the way we move in life. Perhaps they've already learned to fly..

WHAT FANTASIES DO YOU PLAY IN YOUR MIND AS YOU DRIFT OFF TO SLEEP?

...

...

...

IS THERE A DREAM YOU'VE HAD THAT STUCK WITH YOU?

...

...

...

OFTEN OUR DREAMS REVEAL TO US SOMETHING THAT WE'VE LOCKED AWAY. HOW DO YOU FEEL IN YOUR DREAMS: ARE YOU A NEW ADVENTURER, OR A PEACEFUL OLD TRAVELLER?

...

...

WHEN DID YOU LAST TAKE A LEAP OF FAITH?

...

...

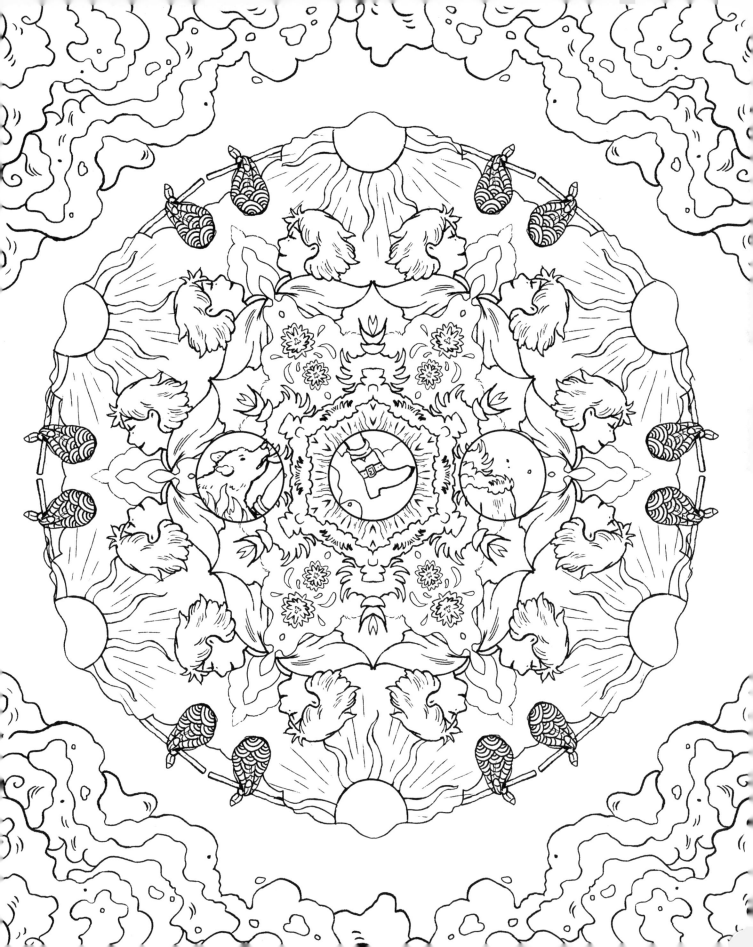

I. the Magus

The trickster magic-weaver, the Magician
has everything he needs in front of him.
What will he make of it all?

The Dreamscape

Unlike the Fool's panorama of potential, the Magus is tucked away in a natural grotto. Surrounded by flowers, with vines dangling from the ceiling, this is a comfortable space, full of secrets and sorcery, teeming with life. Is the golden glow the setting sun, or is it the Magus's halo?

Archetypes

The Magus is the archetypal trickster, using magic to bring his every passing whim into being. In the tarot, he represents the manifestation of intention, connecting with universal potential energy to make something new. Tricksters are the creators, the architects of the world — but they are also all-too-eager to lead us astray. If you meet a trickster in a dream, he could lead you to soaring heights… or the darkest depths within yourself.

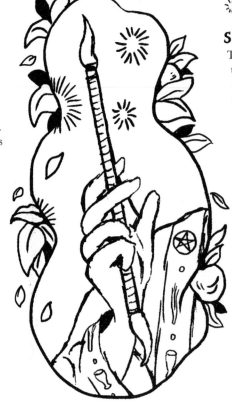

Symbols

The abundant flowers around the Magus fizz with life, while the tools of the four Minor Arcana suits dangle above his head. Usually depicted weilding a wand, this Magus holds a paintbrush and a garland in his hands. Whatever tools you choose, you can always harness the energy of the Magus to weave your own persona magic...

The Dream

You have entered a rich and thriving space, full of potential. The Magus greets you, offers you the tools you need to build your own dream. And yet, there's a surprising twinkle in his eye. What have you always wanted to do, but didn't feel you could achieve it? Now might be the time to try...

Tarot Tip

Tricksters are some of the most interesting mythological characters. Do you feel like you embody that role yourself, or is does someone in your life play the trickster?

COLOR CODE

Magenta, pink, brown, mauve, dark gray,
light green, olive, crimson,
gold, orange, cream.

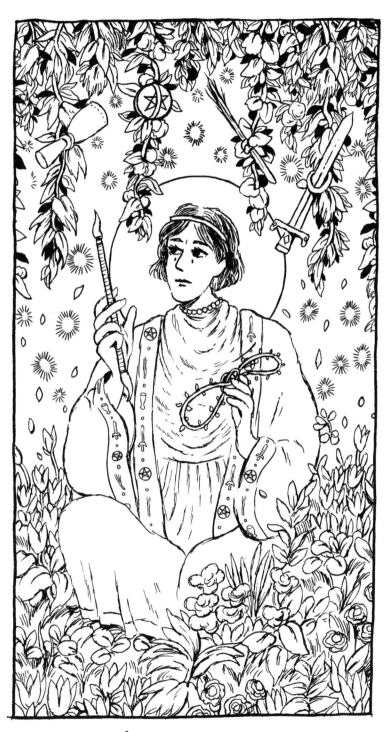

the Magus

REFLECTIONS

What magic can you weave..?

WHAT ARE YOUR TOOLS OF MANIFESTATION?

..

..

WHERE DO YOU FEEL THE MOST CREATIVE?

..

..

..

HAVE YOU EVER HAD A DREAM IN WHICH YOU BUILT YOUR OWN
WORLD? WHAT WAS IT LIKE?

..

..

..

DO YOU EVER FEEL LIKE YOU ARE BLOCKED CREATIVELY? WHAT DO
YOU THINK COULD BE CAUSING THIS?

..

..

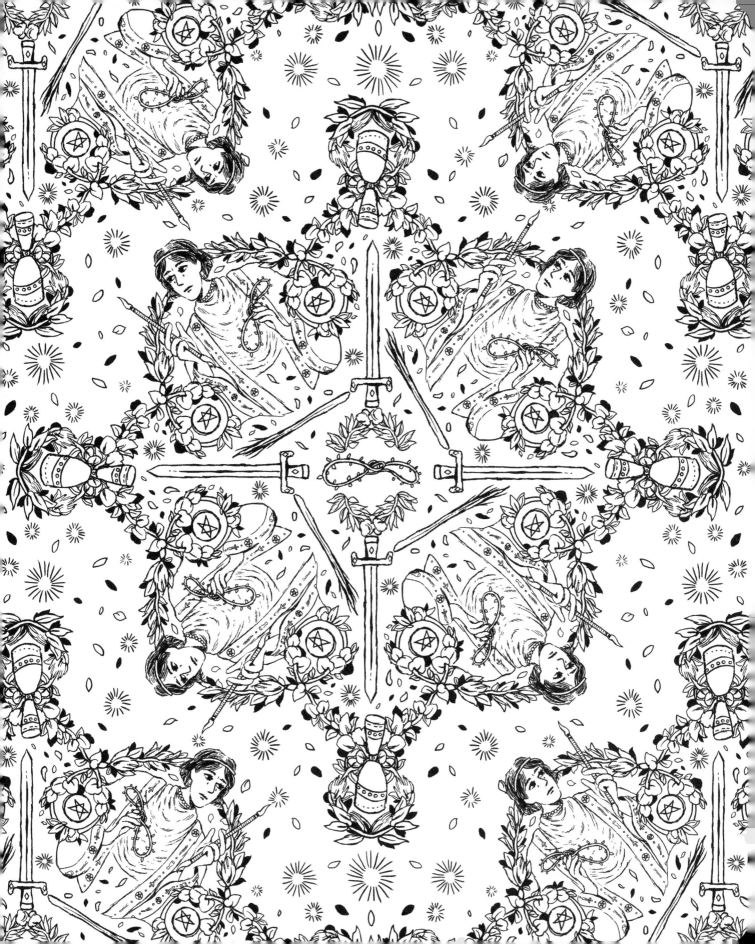

II. the high priestess

The curtains draw back, revealing a woman hidden by a veil. She sits atop a throne of crystal, a slight smile on her face. And as you watch, she opens a door within herself...

The Dreamscape

The High Priestess, like the Magus, is tucked into a secret corner of this dream. Yet, this is grander than the Magus's grotto, a place of wonder and enlightenment. If you wander here, you must prepare to unlock a part of yourself that never knew was closed...

Archetypes

The High Priestess is the guardian of thresholds and wisdom, the divine unconscious in human form. She is memory itself, the reconstruction of everything we have experienced, everyone we have met, and all we are. She knows that there are vast oceans within each of us, worlds we have yet to discover in our own minds. She has built her own pathway to inner enlightenment, but what waits behind your door?

Symbols

Pomegranates dangle above the High Priestess, the fruit that Persephone ate in the Underworld. Life and death literally hang in the balance — also denoted by the black and white curtains that hang each side of the High Priestess. The crescent moon symbolises the subconscious of night, nestled in natural leaves beside the magic-infused crystals of the throne. The book is full of wisdom that will help you open that door...

The Dream

This dream is a transformation. Here you may learn more about yourself. The High Priestess invites you to share in her wisdom, to connect with yourself and the secrets of the universe. Smiling, she urges you to create pathways within, as the greatest mystery is our own selves.

+ ✦ Tarot Tip ✦ +

As a threshold guardian, The High Priestess is synonymous with psychopomp goddesses such as Ereshkigal, Hecate, and Isis. If she keeps appearing in your readings, maybe look into these goddesses. Perhaps The High Priestess is trying to take you on a journey...

COLOUR CODE

Magenta, yellow, gray, brown, orange,
cream, mauve, light gray, peach,
salmon, ice blue, dark gray, gold.

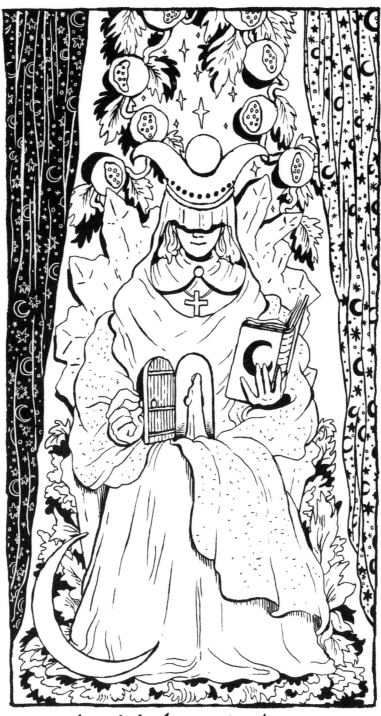

the high priestess

REFLECTIONS

Enlightenment can only come
from self-understanding...

IS THERE A PART OF YOURSELF THAT YOU'VE BEEN LOCKING AWAY?

..

..

IN WHAT SITUATIONS DO YOU FEEL YOU CAN BE MOST YOURSELF?

..

..

..

IS THERE ANYTHING THAT YOU'VE LEARNED THAT REVEALED A PART OF YOURSELF YOU HAD NOT YET DISCOVERED?

..

..

..

WHAT'S A SECRET ABOUT YOURSELF YOU'VE NEVER TOLD ANYONE ELSE?

..

..

..

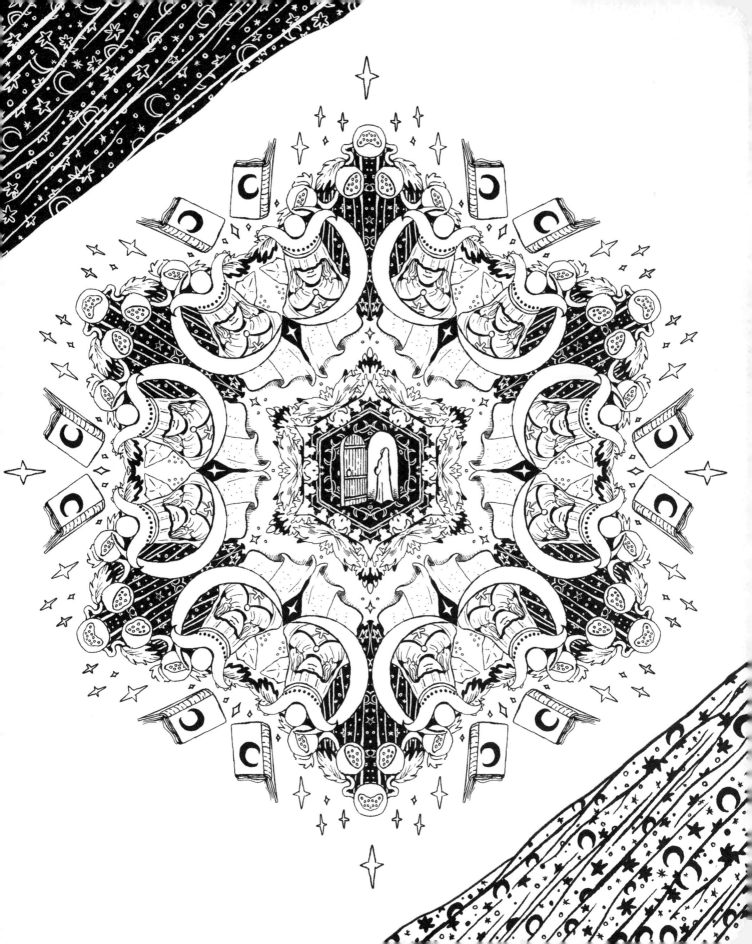

III. the empress

The eternal mother, caretaker of the world. In her garden you will find only wonders...

The Dreamscape

A white sun bleeds red in a vibrant yellow sky. Purple clouds cry delicate tears. The turbulent sea dashes tiny waves onto the Empress's rock. But around her is a garden, verdant life thriving in the most unexpected of places. This is a place you never hoped to reach, but you've found a home here. It's not yours, but maybe you can stay a while.

Archetypes

The Empress is the world-mother, the wellspring from which pours all life and creation. In dreams, she represents our own mothers, but also the mother that is nature itself, and our own nurturing instinct. Nothing can thrive without something to care for it. The Empress calls upon you to open your heart and let life flow out.

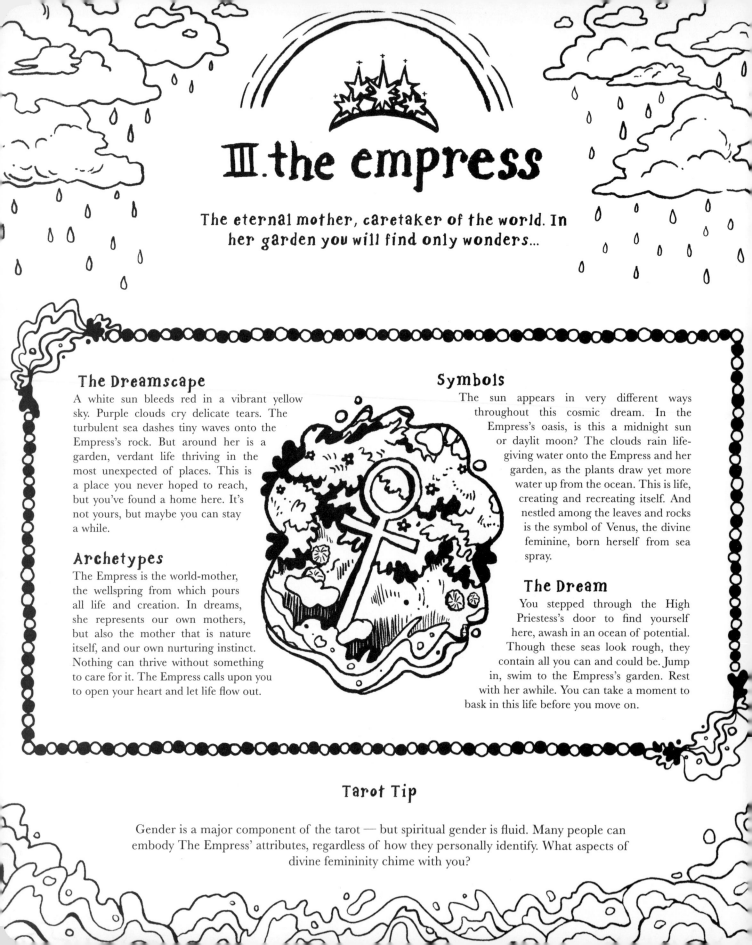

Symbols

The sun appears in very different ways throughout this cosmic dream. In the Empress's oasis, is this a midnight sun or daylit moon? The clouds rain life-giving water onto the Empress and her garden, as the plants draw yet more water up from the ocean. This is life, creating and recreating itself. And nestled among the leaves and rocks is the symbol of Venus, the divine feminine, born herself from sea spray.

The Dream

You stepped through the High Priestess's door to find yourself here, awash in an ocean of potential. Though these seas look rough, they contain all you can and could be. Jump in, swim to the Empress's garden. Rest with her awhile. You can take a moment to bask in this life before you move on.

Tarot Tip

Gender is a major component of the tarot — but spiritual gender is fluid. Many people can embody The Empress' attributes, regardless of how they personally identify. What aspects of divine femininity chime with you?

COLOR CODE

Purple, light gray, gold, orange, mauve,
gray, salmon, magenta, light green,
olive, teal, yellow, green.

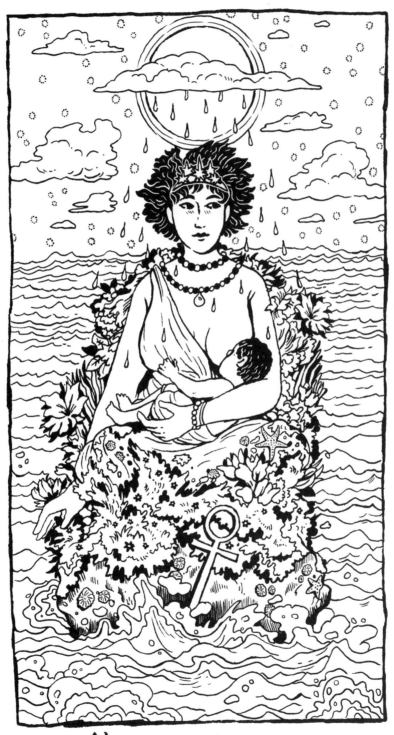

the empress

REFLECTIONS

The best thing in this world is to care for it.

WHO IN YOUR LIFE DO YOU GO TO WHEN YOU NEED COMFORT?

..

..

HOW DO YOU GIVE THAT LOVE TO OTHERS?

..

..

IS THERE ANYONE IN YOUR LIFE WHO YOU WANT TO PROTECT?

..

..

WAS THERE A TIME IN YOUR LIFE WHEN YOU HAD TO OPEN YOURSELF UP TO BEING LOVED?

..

..

..

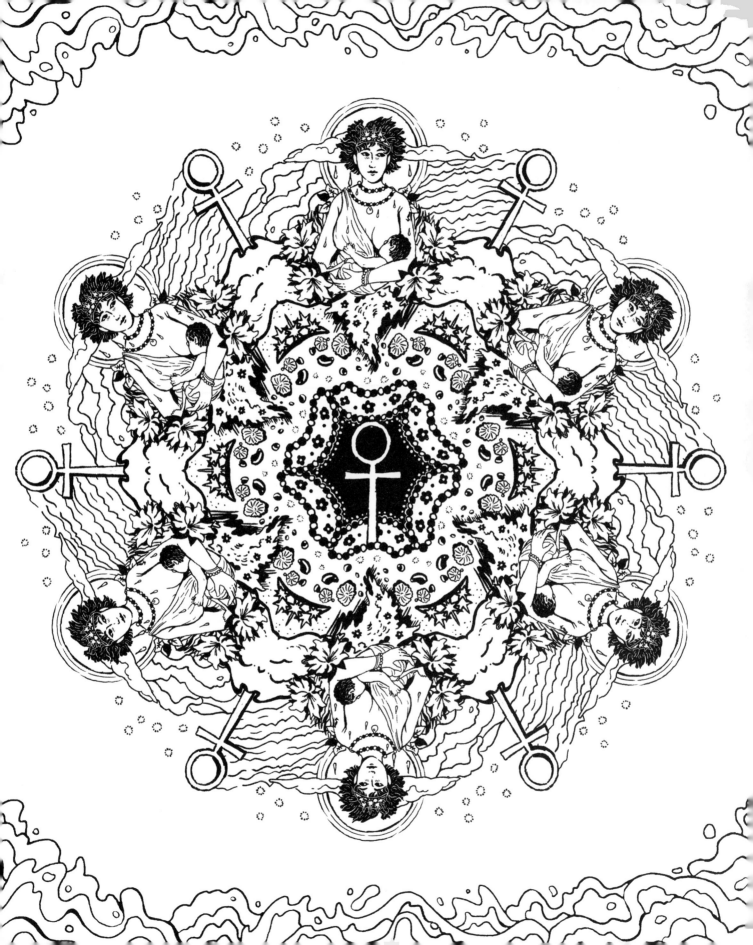

IV. the emperor

*Control over our environment
can lead to great things...*

The Dreamscape

Beyond the Empress's sea lies the Emperor's kingdom. His throne is perched upon a grassy hill, trees exploding into life behind him. This is an imposing space, more challenging than the Empress's safe oasis. And yet, you could carve out a place here, if you can meet the Emperor on his terms.

Tarot Tip

The ram can symbolise many things in esoterica and mythology. From Astrology to the Bible, rams and lambs are a crucial part of how we understand spirituality. What do they mean to you?

Archetypes

The Emperor is the archetypal ruler, the patriarchal figure of control and order. He approaches every problem with logic — but his emotions still run deep. In a dream, he symbolises social authority and father figures, challenging you to define how you relate to him. He has built his empire. How will you build yours?

Symbols

Usually depicted in an urban space, this dreamlike Emperor holds court deep in nature. He's the architect of destiny: just as the trees grow out from his throne, so he encourages you to grow. Feet deep in the grass, the Emperor is grounded in the Earth, completing a natural cycle. The Emperor's face is masked by a ram's skull, while a lamb slumbers in his lap, his shield protecting it from life's dangers. The Emperor's staff is topped with a star — this is all you could achieve if you harness your potential.

The Dream

You have swum the sea and climbed the hill, and you wait before the Emperor. This is a fertile dreamspace, and what you learn here will help you build your future. Feel the grass beneath your feet, watch how the trees grow. Can you become the Emperor of your waking world?

COLOR CODE

Crimson, yellow, gold, teal, light green,
green, pink, magenta, navy, ice blue,
mauve, cream, light gray, brown.

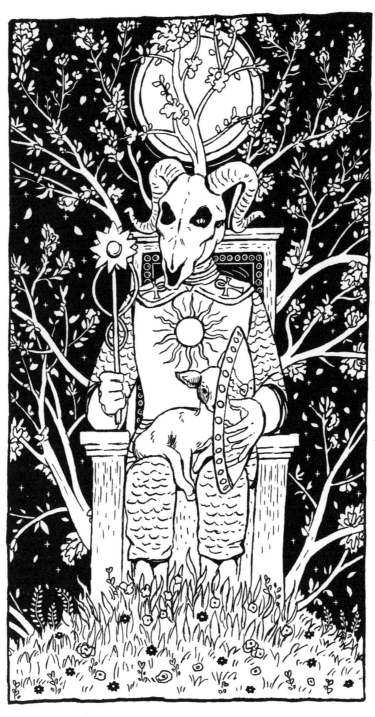

the emperor

REFLECTIONS

The Emperor calls upon you to become your strongest self..

DO YOU IDENTIFY MORE WITH THE EMPEROR OR THE EMPRESS?

..

..

WHAT IN YOUR LIFE ARE YOU HOPING TO BUILD?

..

..

HOW DO YOU RELATE TO SOCIAL AUTHORITY?

..

..

..

WHAT SHIELDS YOU AGAINST LIFE'S HARDSHIPS?

..

..

..

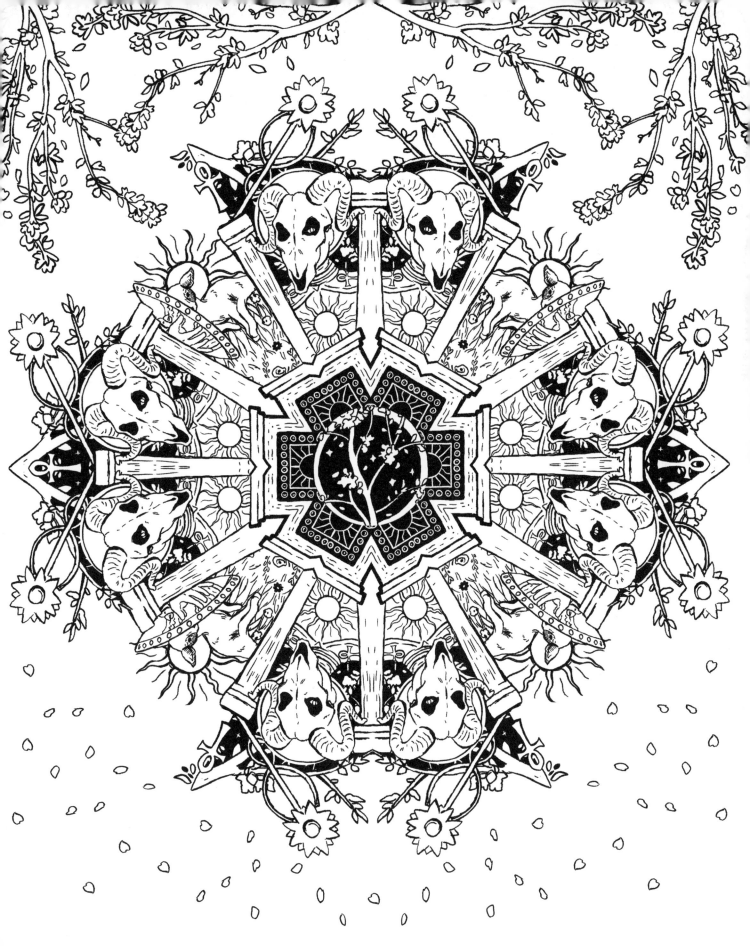

V. the hierophant

The gatekeeper to a secret doctrine awaits...

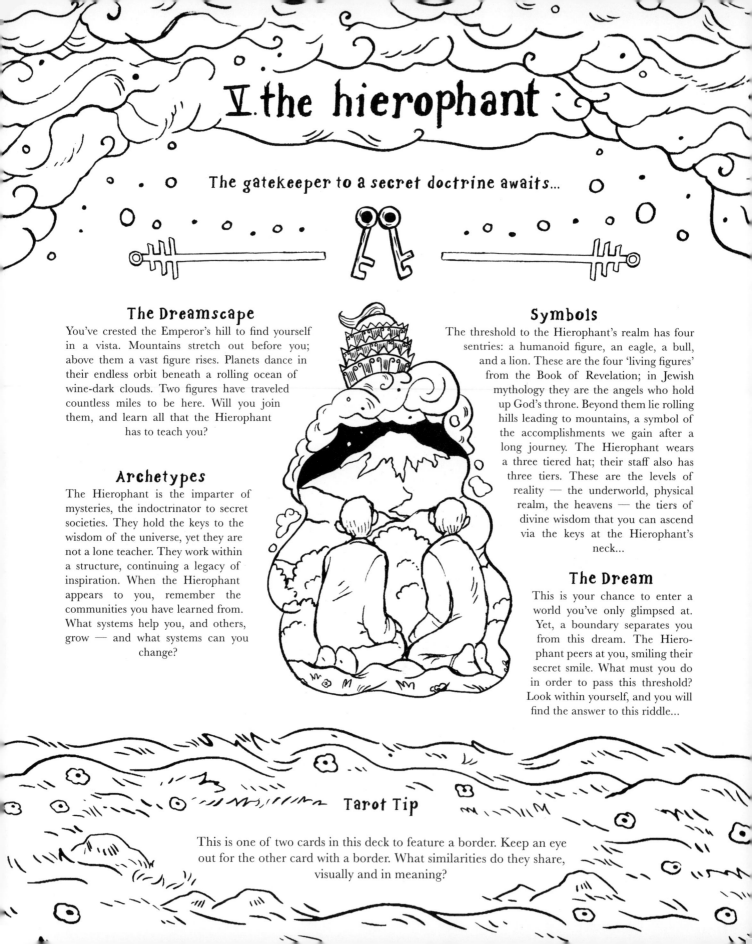

The Dreamscape

You've crested the Emperor's hill to find yourself in a vista. Mountains stretch out before you; above them a vast figure rises. Planets dance in their endless orbit beneath a rolling ocean of wine-dark clouds. Two figures have traveled countless miles to be here. Will you join them, and learn all that the Hierophant has to teach you?

Archetypes

The Hierophant is the imparter of mysteries, the indoctrinator to secret societies. They hold the keys to the wisdom of the universe, yet they are not a lone teacher. They work within a structure, continuing a legacy of inspiration. When the Hierophant appears to you, remember the communities you have learned from. What systems help you, and others, grow — and what systems can you change?

Symbols

The threshold to the Hierophant's realm has four sentries: a humanoid figure, an eagle, a bull, and a lion. These are the four 'living figures' from the Book of Revelation; in Jewish mythology they are the angels who hold up God's throne. Beyond them lie rolling hills leading to mountains, a symbol of the accomplishments we gain after a long journey. The Hierophant wears a three tiered hat; their staff also has three tiers. These are the levels of reality — the underworld, physical realm, the heavens — the tiers of divine wisdom that you can ascend via the keys at the Hierophant's neck...

The Dream

This is your chance to enter a world you've only glimpsed at. Yet, a boundary separates you from this dream. The Hierophant peers at you, smiling their secret smile. What must you do in order to pass this threshold? Look within yourself, and you will find the answer to this riddle...

Tarot Tip

This is one of two cards in this deck to feature a border. Keep an eye out for the other card with a border. What similarities do they share, visually and in meaning?

COLOR CODE

Navy blue, blue, ice blue, aubergine, dark gray, light gray, salmon, pink, magenta, teal crimson, cream, light green, orange, green.

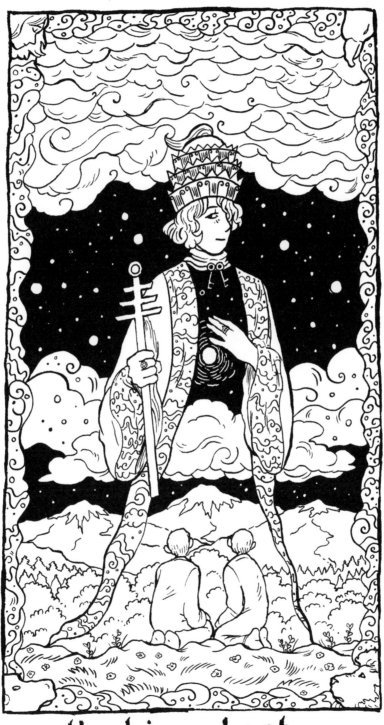

the hierophant

REFLECTIONS

Everything that we learn builds on our
collective knowledge as a people...

WHAT COMMUNITY HAS OPENED DOORS FOR YOU?

..

..

..

IS THERE ANYONE IN YOUR LIFE WHO PLAYS THE ROLE OF THE HIEROPHANT?

..

..

..

WHAT EXISTING SOCIAL OR INSTITUTIONAL STRUCTURE WOULD YOU CHANGE? HOW?

..

..

IS THERE A LEGACY OF IDEAS THAT YOU FEEL LIKE YOU'RE A PART OF?

..

..

..

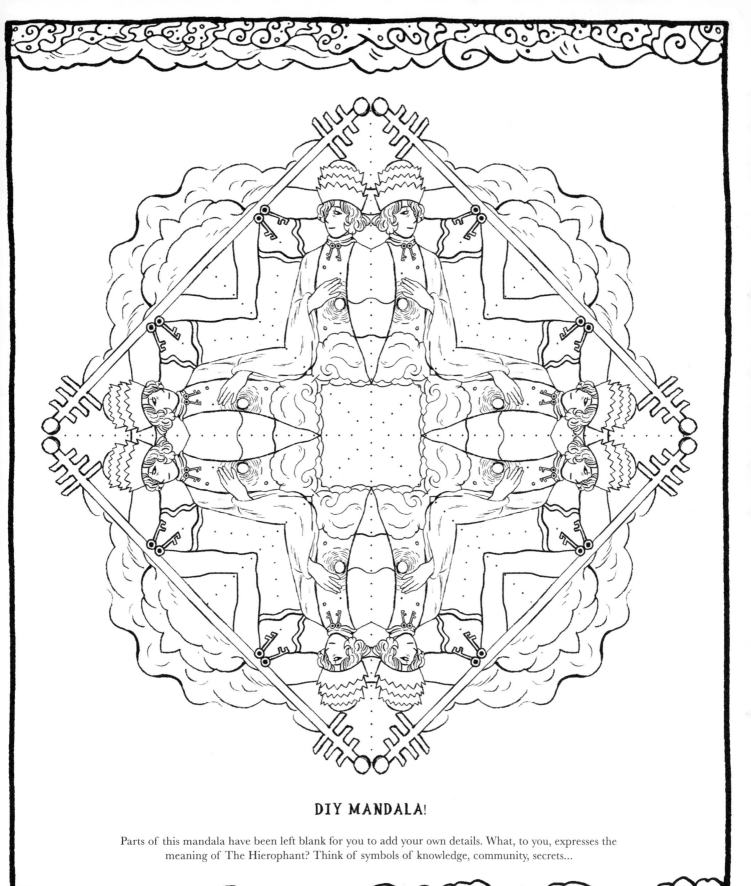

DIY MANDALA!

Parts of this mandala have been left blank for you to add your own details. What, to you, expresses the
meaning of The Hierophant? Think of symbols of knowledge, community, secrets...

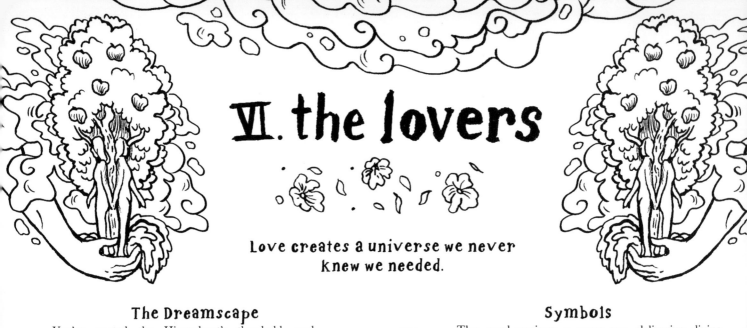

VI. the lovers

Love creates a universe we never knew we needed.

The Dreamscape

You've passed the Hierophant's threshold, and the cosmos explodes in front of you. This is the inner and outer world as one, a kaleidoscope of feeling unfurling into infinity. Love makes you soar among the clouds, painted pink and gold and blue by the sunrise of something new. Thriving with color and emotion, this space is overwhelming — but great inspiration can be found if you only open yourself to it..

Archetypes

What does it mean to be a lover? To be loved is to be known, in all our imperfections — and it can be terrifying to put your heart in another's hands. But the lover is eternally hopeful. This dream is the fall and the reward; the inspiration that you find within yourself, and the joy you find in others. It's finally feeling like you belong, self-love affirmed by the love of another. It's what you discover when love unlocks your doors.

Symbols

The angel conjures a green sun, delivering divine wisdom; they hold the Tree of Knowledge, the choice humanity made to take a risk, to claim consciousness and take a bite of destiny. Every time we fall in love we make that same choice again. This can be divisive: the woman standing before the tree turns away from her inner self. Yet her conflict is resolved by the men gathered around the other tree, which represents the gardens that we build for ourselves.

The Dream

Here's the thing about love. It forces us to be known by others in a way we cannot control. The deeper we fall, the more the universe opens to us. This process is not easy. But it is euphoric. There is an understanding that we cannot reach except through love. It challenges the way we see ourselves and others, it expands our own universes. Vast gardens are created within ourselves, and all we can do is reach out and share this garden with someone else. In this dream, you can do anything. But it is only half the story...

Tarot Tip

The Lovers card mirrors The Devil in more ways than one: they are two halves of a whole, two sides of the same story. They may be separated by other cards, but in this deck they are best understood together...

COLOR CODE

Light green, olive, yellow, gold, orange,
cream, magenta, crimson, pink, salmon,
peach, mauve, purple, green.

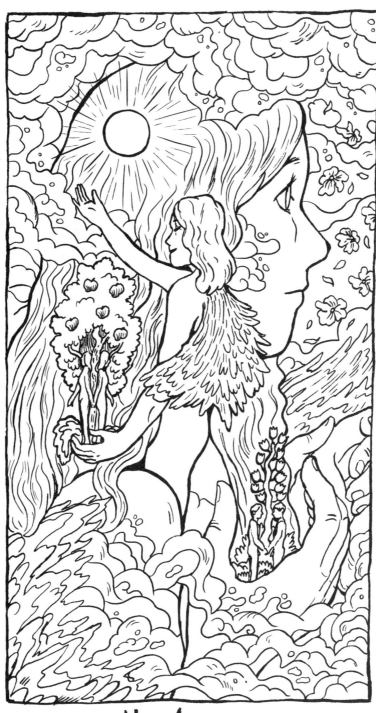

the lovers

REFLECTIONS

Love comes in many forms...

HAVE YOU EVER MET SOMEONE
WHO MADE YOU SUDDENLY
UNDERSTAND LOVE SONGS?

..
..
..
..
..
..

WHAT IS THE MOST PROFOUND
LOVING RELATIONSHIP IN YOUR
LIFE? HOW DID IT CHANGE YOU?

..
..
..
..
..
..

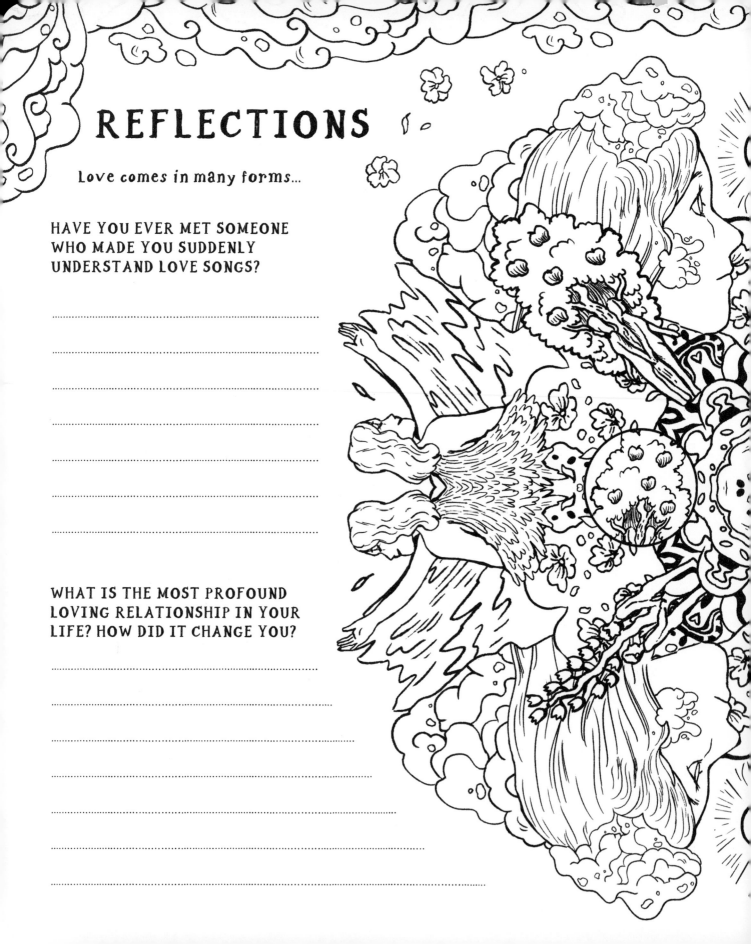

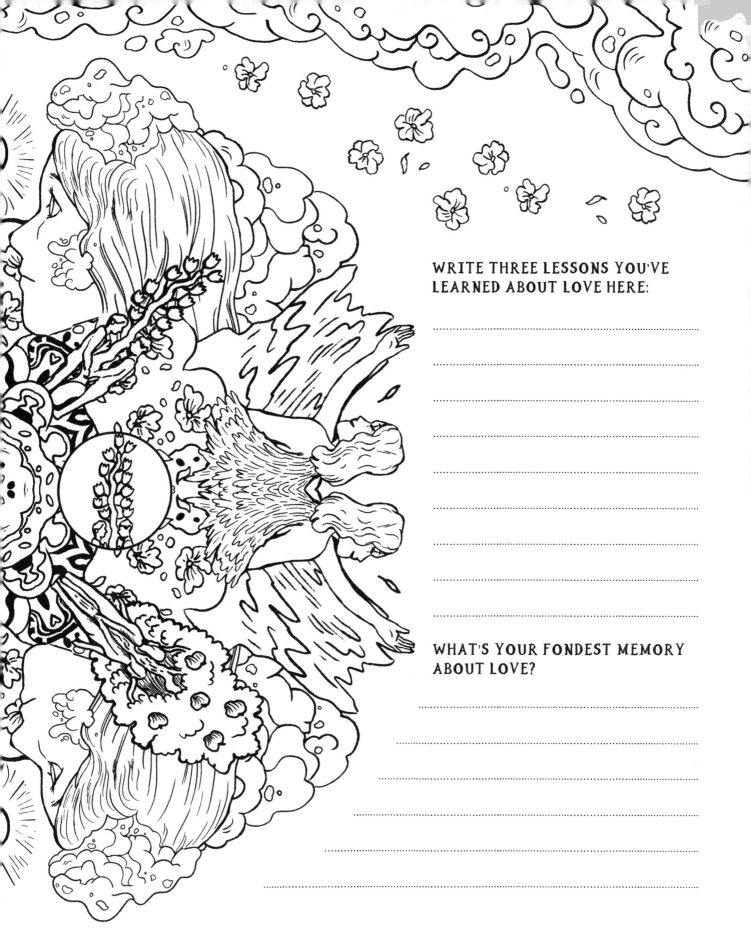

WRITE THREE LESSONS YOU'VE
LEARNED ABOUT LOVE HERE:

...

...

...

...

...

...

...

...

WHAT'S YOUR FONDEST MEMORY
ABOUT LOVE?

...

...

...

...

...

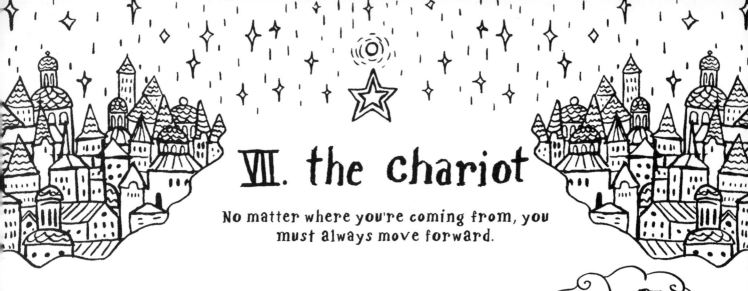

VII. the chariot

No matter where you're coming from, you must always move forward.

The Dreamscape

Out of The Lovers' paradise, you are greeted by two lions pulling a chariot inexorably forward through an ocean of lurid red clouds. Behind the chariot's billowing, starry canopy, you spy a twilight city, spires and towers fading to black against the night sky. Should you journey to the city, or follow where the chariot leads?

Archetypes

Emblematic of forward motion, chariots are also tied to victory: weren't conquering heroes cheered through the streets in this way? Of course, chariots also carried soldiers to war — and this chariot isn't moving into the city, and its adoring crowds, but away from it. Will it carry you to war, and victory, or is its rider on a solo journey of discovery?

Symbols

The black and white lions are the harbingers of destiny, carrying the charioteer forward. Symbolising dark and light, the lions are the duality of existence itself. The charioteer has harnessed them, and you notice that his eyes are closed. Has he placed ultimate faith in his destiny, so he doesn't need to look where he's going? Or perhaps he has reached a heightened sense of awareness: realising you're in a dream when you're dreaming means that you can grasp the reins and take control...

The Dream

The forward motion of your sleeping mind carries you into a new stage of life. Are you feeling stuck, or are you swept along by fate? The best thing is always to board this train, and to ride the chariot to its ultimate destination. You'll know where you're going when you get there.

Tarot Tip

Black and white objects frequently appear in the tarot. Seek out the other black and white objects in the tarot, and compare the cards... how are they the same, and how are they different?

COLOR CODE

Navy blue, teal, magenta, yellow,
purple, crimson, peach, gray,
light gray, dark gray.

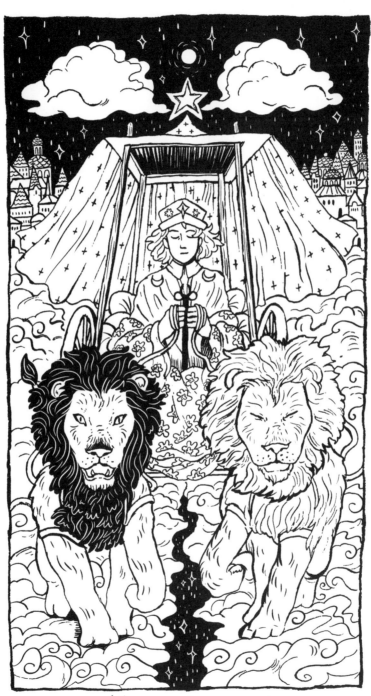

the Chariot

REFLECTIONS

The Chariot waits for no-one...

WHERE DO YOU THINK YOUR LIFE IS HEADING?

..
..
..

DO YOU FEEL LIKE YOU'RE DRIVING YOUR DESTINY, OR DOES FATE HAVE THE REINS?

..
..
..

WHAT IN YOUR LIFE IS PULLING YOU FORWARDS?

..
..
..

WAS THERE A TIME IN YOUR LIFE WHEN YOU FELT TOTALLY GUIDED BY INSTINCT?

..
..
..

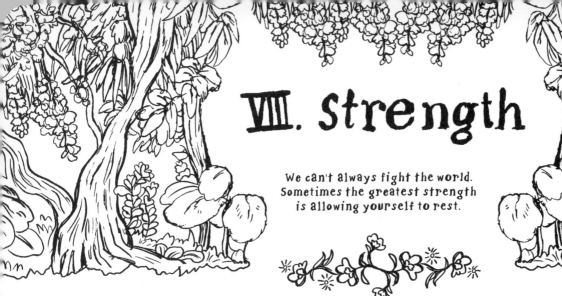

VIII. Strength

*We can't always fight the world.
Sometimes the greatest strength
is allowing yourself to rest.*

The Dreamscape

The dynamic thrust of The Chariot has led you here, to Strength's quiet grove. The outside world melts away. It's just you, and her, and the lion. Wildflowers teem around you as the trees cluster together to create a rich canopy. It's quiet here, a peaceful haven.

Archetypes

The lion is your inner wildness, that part of yourself that keeps fighting no matter what. But it can also be troublesome. It could be your inner turmoil. The girl keeps it in check. Though the lion snarls, she places her hand gently in its mouth. They are one thing, really. The girl needs to feel the lion's power. It keeps her going. What do you fall back on, when times grow tough?

Symbols

The flowers and trees are life abundant: even in the most desperate of times, life will always find a way to thrive. This is the garden of your soul, all the potential for creation that you hold within you. The girl is the ego, the lion is the id. The two must be in harmony in order for the self to be whole.

The Dream

This is the inner world, the part within yourself that will never break, no matter how battered and broken you feel. The lion will roar against the world. It does not need to be tamed, just understood. Close your eyes. Connect with that part of yourself that still wants to fight. It will keep you going, even if you need to rest for now.

TAROT TIP

Strength is depicted very differently in each deck. If you have any other decks, look for Strength. How does the art shift the meaning of the card? Which version resonates with you most?

COLOR CODE

Orange, magenta, pink, peach, gold,
purple, dark gray, yellow,
cream, salmon.

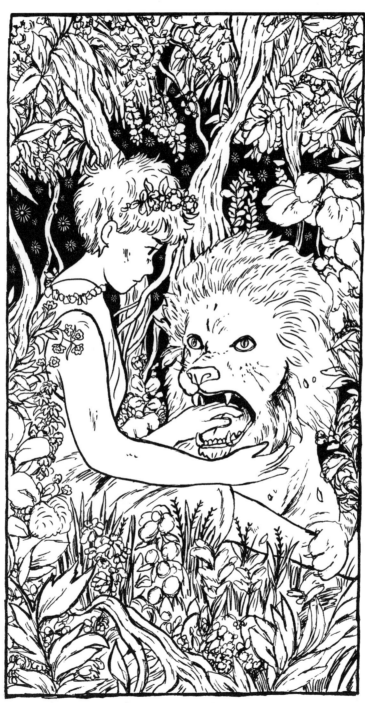

Strength

REFLECTIONS

Our greatest strengths come from within...

WHAT KEEPS YOU GOING IN HARD TIMES?

..

..

..

WHERE DO YOU DRAW STRENGTH FROM?

..

..

..

IS THERE A TIME WHEN YOU FELT TESTED TO YOUR LIMIT? HOW DID YOU GET YOURSELF THROUGH?

..

..

..

LIST YOUR STRONGEST ATTRIBUTES HERE— AND REMEMBER THEM NEXT TIME YOU FEEL LIKE YOU'RE BREAKING.

..

..

..

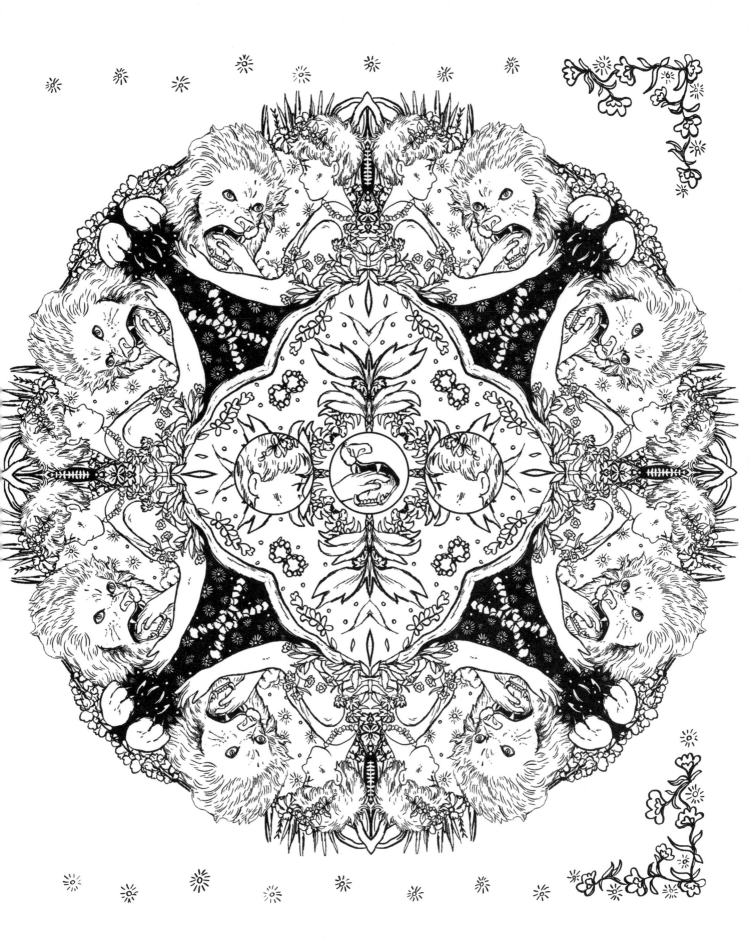

IX. the hermit

Solitude is sometimes all we need.

The Dreamscape

This is the nexus of the universe, galaxies swirling into existence. Nebulous purple clouds surge around an immense gas giant, its rings spun by the smoke from the Hermit's torch. You can't remember how you came to be at this mountaintop: what matters is that you're here, now, totally in the moment.

Archetypes

Hermits play a crucial archetypal role in our collective mythologies. They are the wandering wizards, the sorcerers perched on rocky crags, the ancient secret-holders. Through their isolation they have gained knowledge the rest of us can scarcely guess. When The Hermit appears to you, it's time to retreat inward — there are greater universes within you than you would expect, and only alone can you scale the lofty peaks of your mind.

Symbols

Robed in a shroud of mystery, the Hermit stands atop mountainous peaks: the same ones you glimpsed earlier from the Hierophant's hall. Accompanying the Hermit is a black cat, the folkloric guardian of luck. The Hermit's torch blazes with the truth of the cosmos, tendrils of smoke reaching up into the heavens. And is that Saturn, hanging heavy in the sky?

The Dream

A supernova of consciousness is a rare gift. The Hermit does not speak to you: they are caught in the infinity of their being, in total harmony with the universe. Some journeys can only be taken alone. This dream comes once in a lifetime. Pay attention to the lessons it teaches you.

TAROT TIP

Named for Roman god of time, the planet Saturn plays a crucial role in Astrology. Upon its return, you will be challenged to set limits and responsibilities for yourself, all the while being moved to a new stage of your existence. Under Saturn's will, we must all harness the reflective powers of The Hermit.

COLOR CODE

Purple, pink, yellow, mauve, aubergine,
navy blue, teal, ice blue, orange,
cream, dark gray.

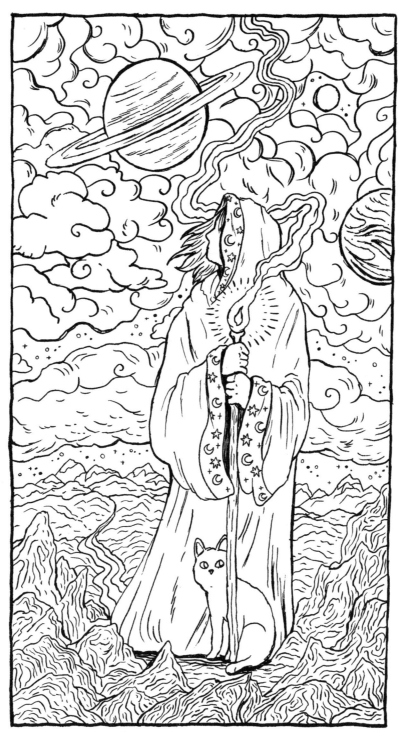

the hermit

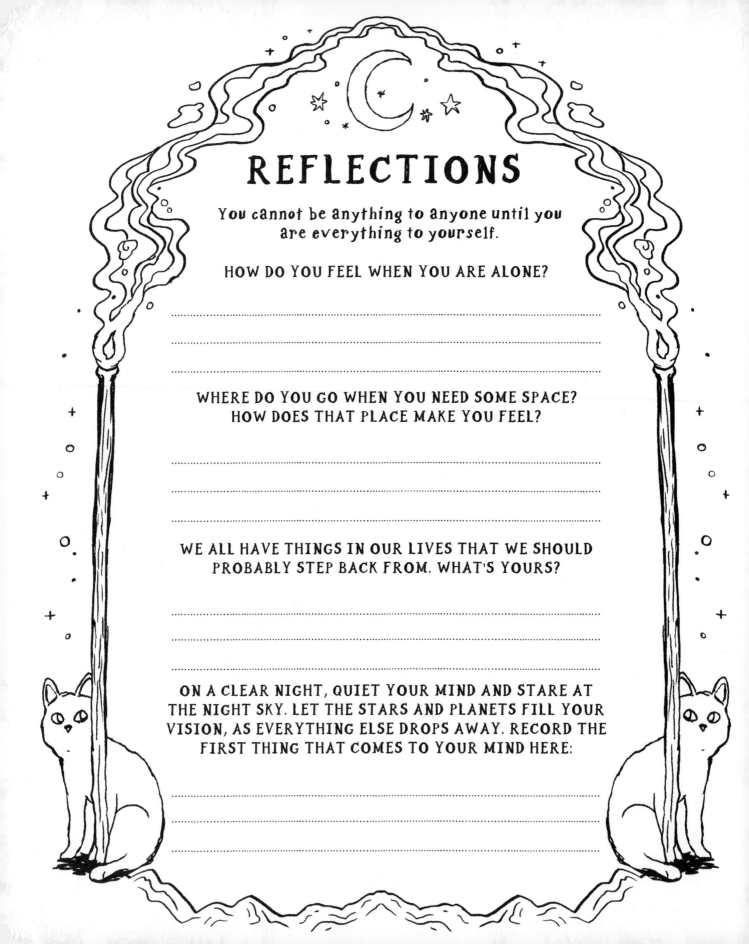

REFLECTIONS

You cannot be anything to anyone until you are everything to yourself.

HOW DO YOU FEEL WHEN YOU ARE ALONE?

..
..
..

WHERE DO YOU GO WHEN YOU NEED SOME SPACE? HOW DOES THAT PLACE MAKE YOU FEEL?

..
..
..

WE ALL HAVE THINGS IN OUR LIVES THAT WE SHOULD PROBABLY STEP BACK FROM. WHAT'S YOURS?

..
..
..

ON A CLEAR NIGHT, QUIET YOUR MIND AND STARE AT THE NIGHT SKY. LET THE STARS AND PLANETS FILL YOUR VISION, AS EVERYTHING ELSE DROPS AWAY. RECORD THE FIRST THING THAT COMES TO YOUR MIND HERE:

..
..
..

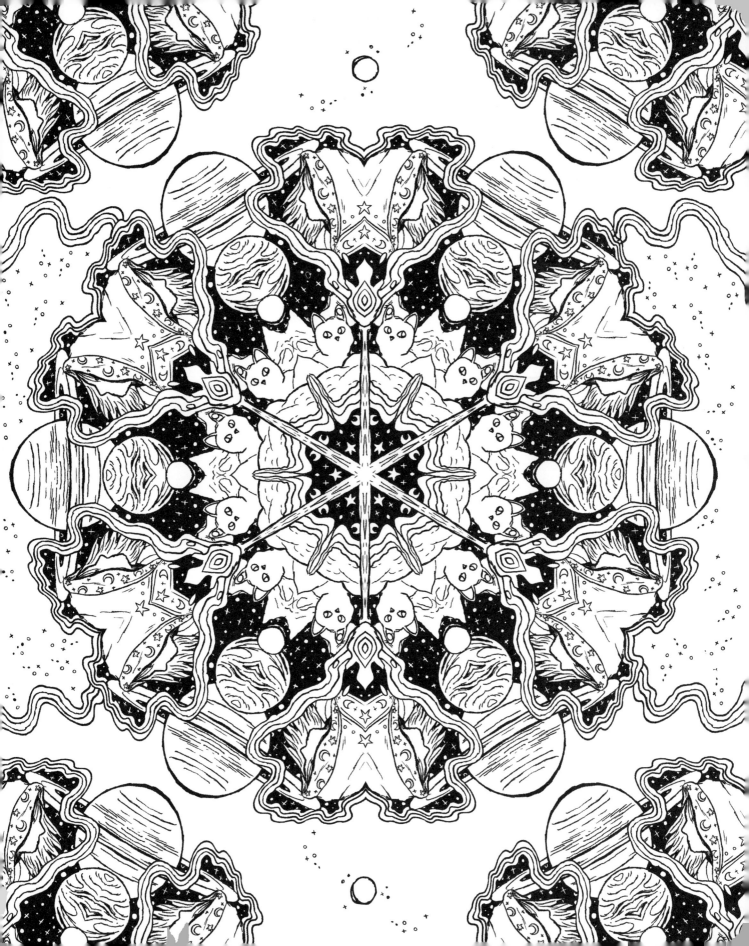

X. Wheel of Fortune

The wheel keeps turning...

The Dreamscape

Rising up above the Hermit's clouds, you enter a world between worlds. A great sphinx sits weightlessly behind a giant wheel, tethered to magenta clouds by flowing green fabrics. The border you saw before has shifted to the background. Is this the secret wisdom unlocked by the Hierophant?

Archetypes

The sphinx is the gatekeeper to whatever adventure lies beyond their threshold. Denizens of the Egyptian sun-god Ra, sphinxes are regal riddlers. They will test you with twisting words and double meanings, offering you entrance only if you prove your worth. Meanwhile, the wheel is the archetype of fortune: at many points in life, we are either raised to the top of the wheel, or crushed beneath it...

Symbols

At the corners of the cards are the same 'living figures' as appeared by the Hierophant. They are often portrayed as the fixed signs of the Zodiac; they represent the four elements and the four corners of the Earth. The slumbering moon is reflected above and below the sphinx, epitomising the esoteric principle of 'as above, so below' — and because the moon is asleep in a dream, this denotes heightened awareness. The wheel is life itself, time always in motion, fate appearing as chaos to the uninitiated mind.

The Dream

Here, you float, disconnected from your slumbering body. The chaos of the waking world is contained within symbols, and the great clock of the universe is guarded by the pharaohs' crypt-keeper. If there's a lesson to learn here, it's that sometimes we must succumb to the unknowable flow of fate...

TAROT TIP

In what other cards does the moon have a face? Are its eyes open or closed?

COLOR CODE

Light green, olive, peach, cream,
dark gray, purple, navy blue,
orange, magenta, pink, green.

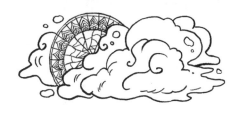

Wheel of Fortune

REFLECTIONS

The sphinx's head turns, and asks you these questions...

✧ HAVE YOU NOTICED ANY RECURRING SYMBOLS IN YOUR DREAMS? ✧

...

...

...

✧ WHAT DO YOUR PERSONAL DREAM-SYMBOLS MEAN? (FOR EXAMPLE: FOR YOU, RISING WATER COULD MEAN A SENSE OF RISING ANXIETY, WHILE FOR SOMEONE ELSE IT COULD RELATE TO A CHILDHOOD FEAR OF THE OCEAN.) ✧

...

...

...

WHEN IN YOUR LIFE HAVE YOU FELT CRUSHED BY THE WHEEL? AND WHEN WERE YOU RAISED TO ITS TOP?

...

...

...

✧ DO YOU FEEL LIKE THERE IS SOMETHING YOU WERE DESTINED TO DO? ✧

...

...

...

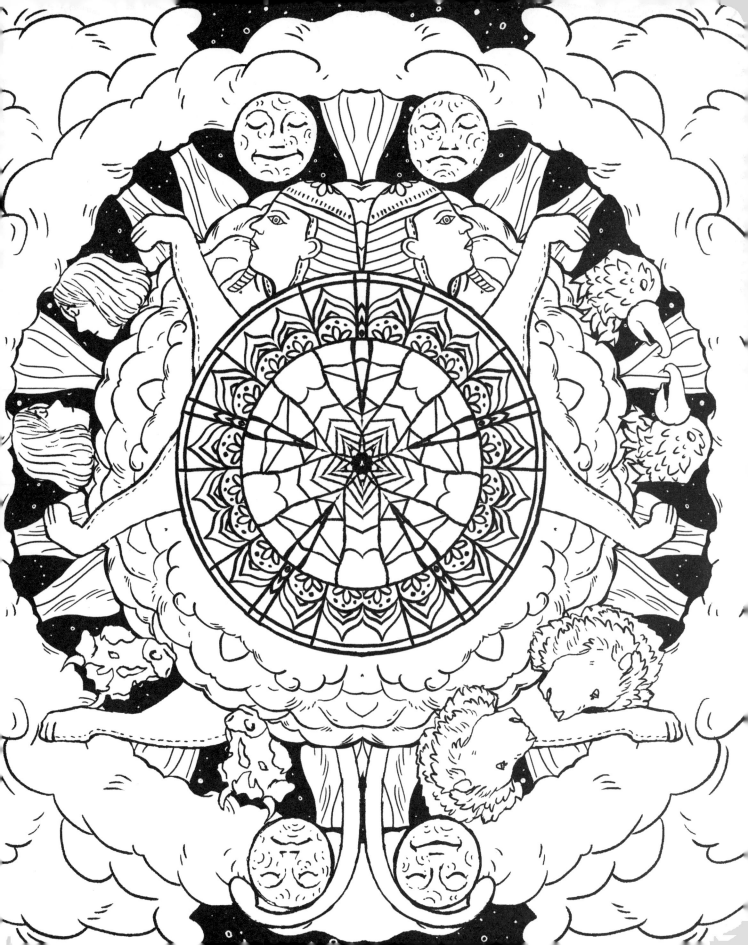

XI. Justice

Everything that happens is a consequence of what has come before...

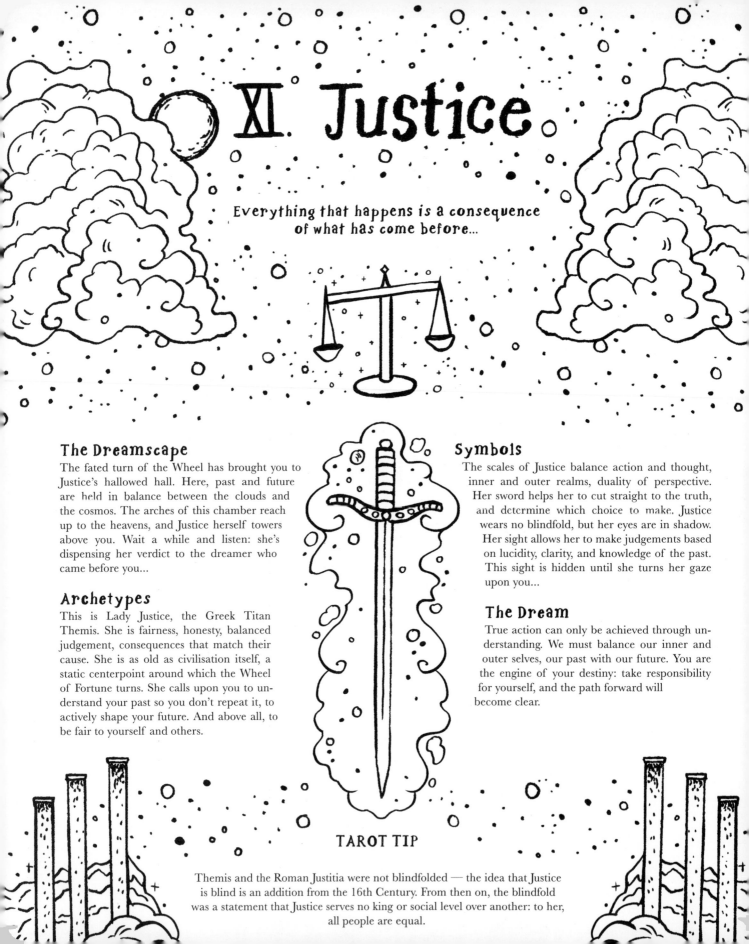

The Dreamscape

The fated turn of the Wheel has brought you to Justice's hallowed hall. Here, past and future are held in balance between the clouds and the cosmos. The arches of this chamber reach up to the heavens, and Justice herself towers above you. Wait a while and listen: she's dispensing her verdict to the dreamer who came before you...

Archetypes

This is Lady Justice, the Greek Titan Themis. She is fairness, honesty, balanced judgement, consequences that match their cause. She is as old as civilisation itself, a static centerpoint around which the Wheel of Fortune turns. She calls upon you to understand your past so you don't repeat it, to actively shape your future. And above all, to be fair to yourself and others.

Symbols

The scales of Justice balance action and thought, inner and outer realms, duality of perspective. Her sword helps her to cut straight to the truth, and determine which choice to make. Justice wears no blindfold, but her eyes are in shadow. Her sight allows her to make judgements based on lucidity, clarity, and knowledge of the past. This sight is hidden until she turns her gaze upon you...

The Dream

True action can only be achieved through understanding. We must balance our inner and outer selves, our past with our future. You are the engine of your destiny: take responsibility for yourself, and the path forward will become clear.

TAROT TIP

Themis and the Roman Justitia were not blindfolded — the idea that Justice is blind is an addition from the 16th Century. From then on, the blindfold was a statement that Justice serves no king or social level over another: to her, all people are equal.

COLOR CODE

Orange, gold, pink, magenta, aubergine, gray, light gray, crimson, navy blue, brown, peach.

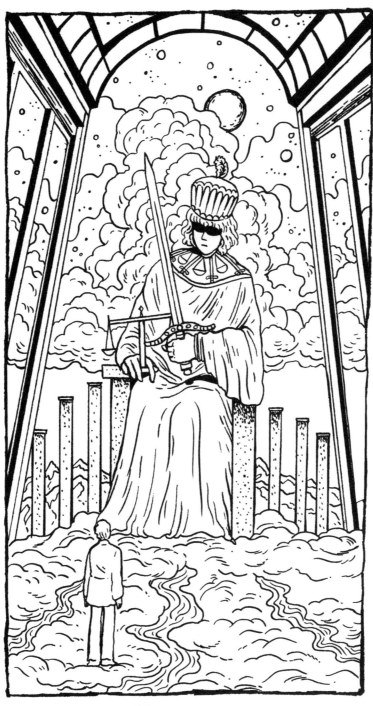

Justice

REFLECTIONS

Your greatest responsibility is your own life...

WHAT EVENTS IN YOUR PAST SHAPED WHO YOU ARE TODAY?

...

...

...

HOW ARE YOU CREATING YOURSELF, AT THIS POINT IN YOUR LIFE?

...

...

...

DO YOU APPLY THE SAME STANDARDS OF JUDGEMENT TO YOURSELF, AS YOU DO OTHERS?

...

...

...

IS THERE A DECISION YOU'RE CURRENTLY TRYING TO MAKE?

...

...

...

...

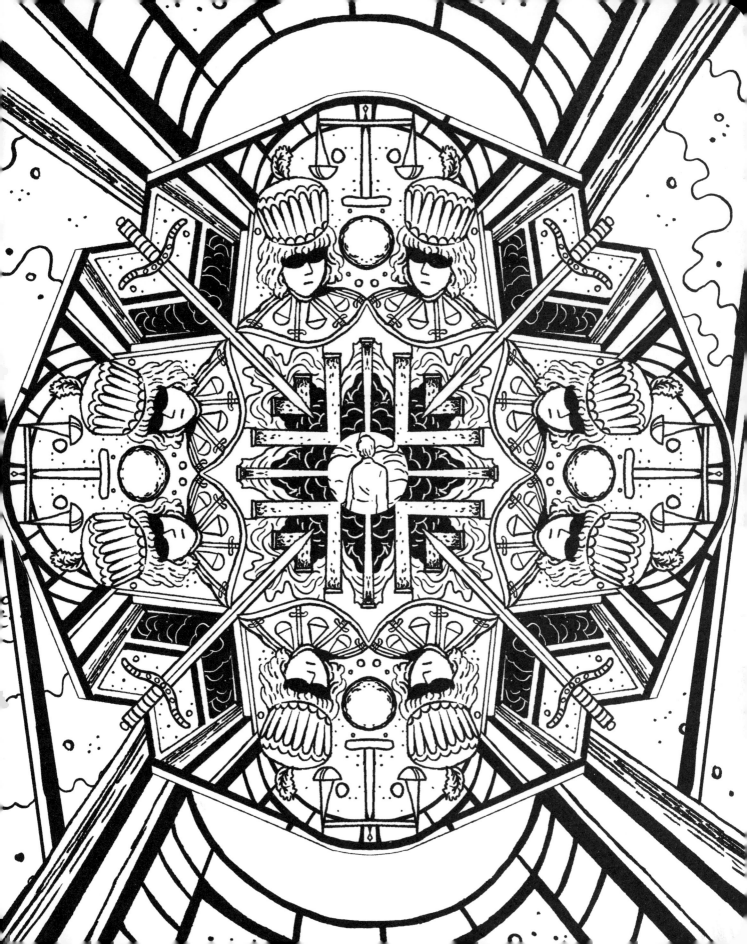

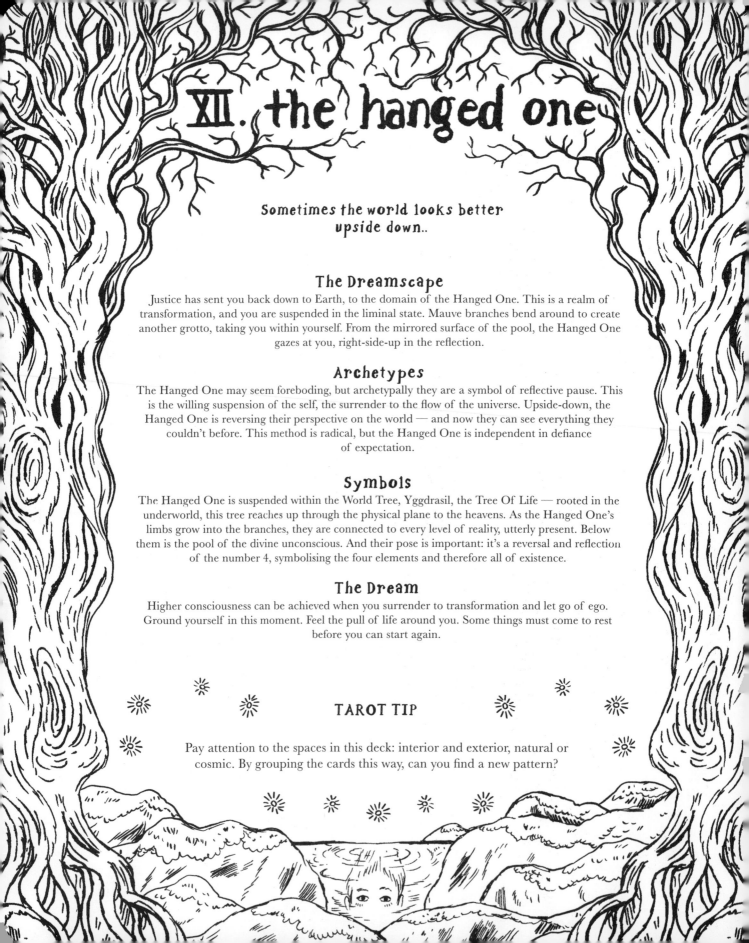

XII. the hanged one

Sometimes the world looks better
upside down..

The Dreamscape

Justice has sent you back down to Earth, to the domain of the Hanged One. This is a realm of transformation, and you are suspended in the liminal state. Mauve branches bend around to create another grotto, taking you within yourself. From the mirrored surface of the pool, the Hanged One gazes at you, right-side-up in the reflection.

Archetypes

The Hanged One may seem foreboding, but archetypally they are a symbol of reflective pause. This is the willing suspension of the self, the surrender to the flow of the universe. Upside-down, the Hanged One is reversing their perspective on the world — and now they can see everything they couldn't before. This method is radical, but the Hanged One is independent in defiance of expectation.

Symbols

The Hanged One is suspended within the World Tree, Yggdrasil, the Tree Of Life — rooted in the underworld, this tree reaches up through the physical plane to the heavens. As the Hanged One's limbs grow into the branches, they are connected to every level of reality, utterly present. Below them is the pool of the divine unconscious. And their pose is important: it's a reversal and reflection of the number 4, symbolising the four elements and therefore all of existence.

The Dream

Higher consciousness can be achieved when you surrender to transformation and let go of ego. Ground yourself in this moment. Feel the pull of life around you. Some things must come to rest before you can start again.

TAROT TIP

Pay attention to the spaces in this deck: interior and exterior, natural or cosmic. By grouping the cards this way, can you find a new pattern?

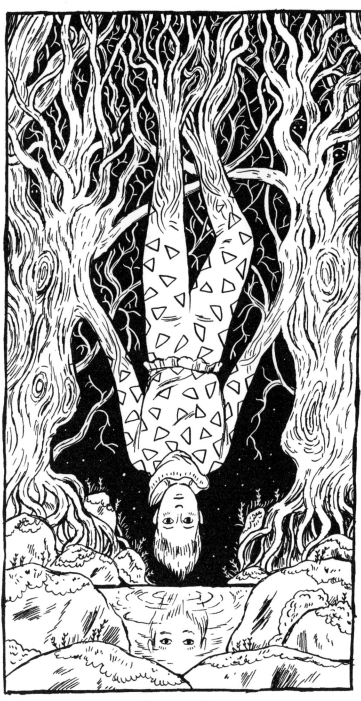

the hanged one

REFLECTIONS

Serenity can only be reached when we slow down and stop.

IS THERE A CHANGE IN YOUR LIFE THAT YOU'VE BEEN RESISTING?

..

..

..

DOES THE IDEA OF TOTAL SELF-SURRENDER FRIGHTEN, OR ENTICE YOU?

..

..

..

TAKE A SITUATION THAT HAS BEEN PLAGUING YOU AND REVERSE YOUR EXPECTATIONS OF IT. HOW DOES THIS CAST NEW LIGHT ON THE ISSUE? WHAT EMOTIONS DOES THIS PERSPECTIVE EVOKE?

..

..

..

WE SPEND OUR LIVES RACING FROM ONE MOMENT TO THE NEXT. WHAT CAN YOU LEARN FROM THIS MOMENT, IN ALL ITS IMPERFECTIONS, EVEN IF IT IS A TIME OF FRUSTRATION OR TRANSITION?

..

..

..

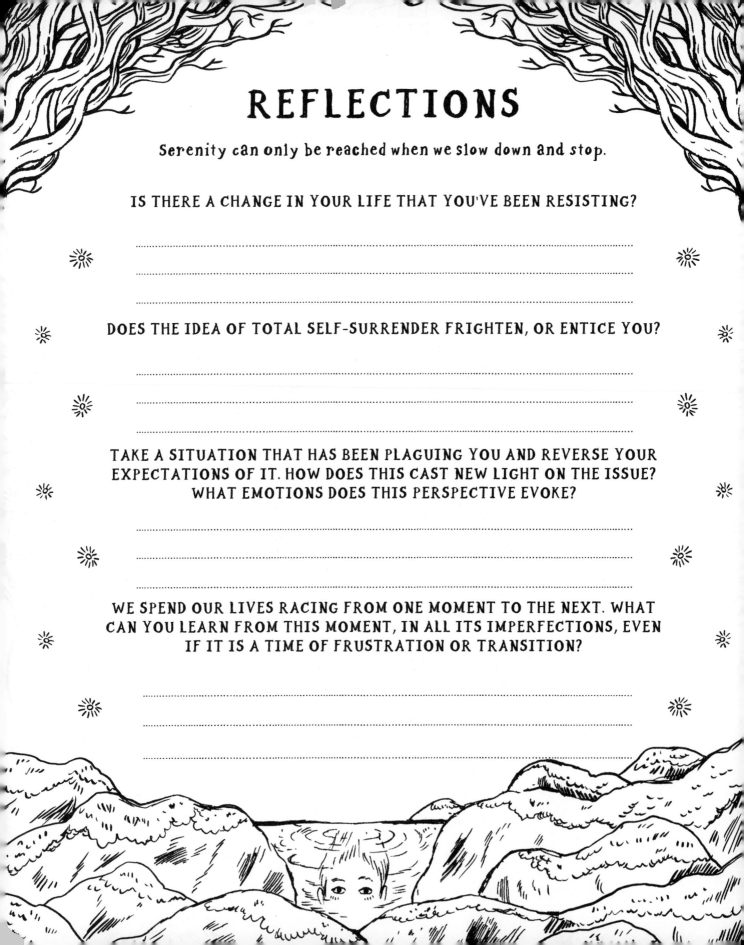

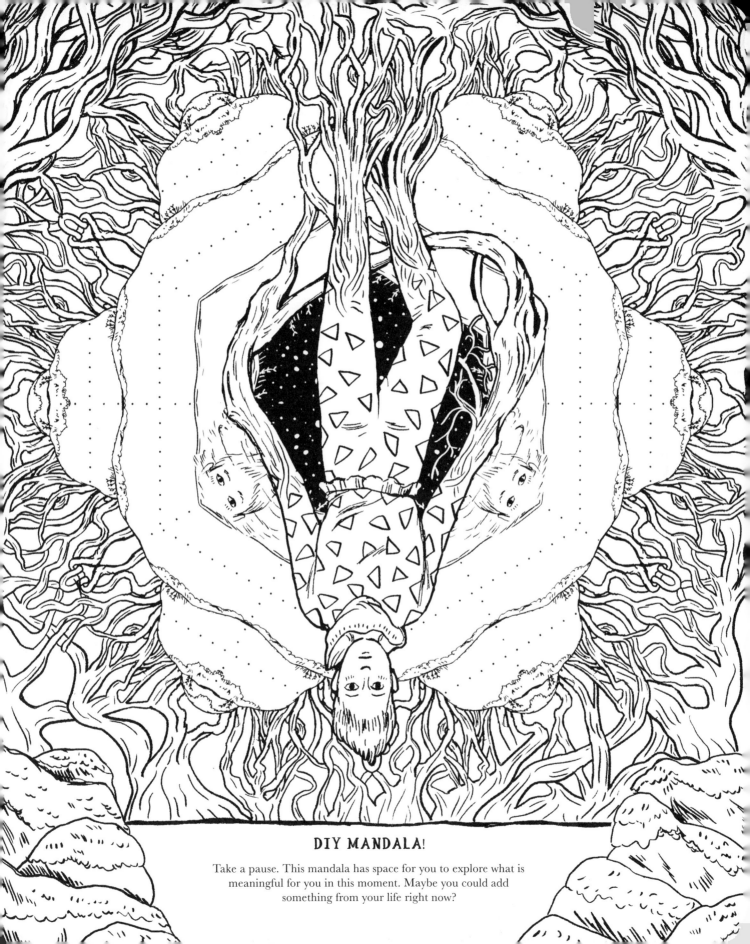

DIY MANDALA!

Take a pause. This mandala has space for you to explore what is meaningful for you in this moment. Maybe you could add something from your life right now?

XIII. Death

Don't fear the reaper..

The Dreamscape

You plunge into the Hanged One's pool, and emerge in Death's turbulent sea. A skeletal rider atop a pale horse turns its head to view you. This is not your time: you are but a witness to Death's endless march through the storm-tossed sea to the blood-red, setting sun… or is it rising?

Archetypes

Death is inevitable. As mortal beings we fear it, but that fear is not really of death but the ultimate unknown. Yet, Death has always been an essential part of life, as it clears the way for more life. When Death appears in a dream, it may be signalling great change, unutterable fears that your conscious mind hasn't dealt with yet, or a new beginning. And sometimes, it signifies all three.

Symbols

In this slumber, Death is depicted as a skeleton, the last remainder of a decomposing body, a glimpse of eternity. The scythe, of course, is that which Death uses to cut down souls — and yet it's also the tool of harvest, bringing in what we need to sustain us. The pale horse is life's purity and constant movement forward — movement which can only be facilitated by Death.

The Dream

Death is the only proof we have that we are alive. In many ways, it is selfhood: knowledge of the self comes from the knowledge that one day the self will end — and with this knowledge comes the urgency with which life must be grasped. Dreams in which we die are a reminder of this, a reminder that when we wake we are alive, and we will be alive, as long as we keep waking..

TAROT TIP

This portrayal of Death is reminiscent of Le Danse Macabre, a genre of art which depicted humans dancing with Death. This was inspired by the Black Plague, as people came face to face with their own mortality, and Death became a part of everyday life.

COLOR CODE

Purple, aubergine, ice blue,
magenta, pink, crimson, yellow,
gray, orange, mauve.

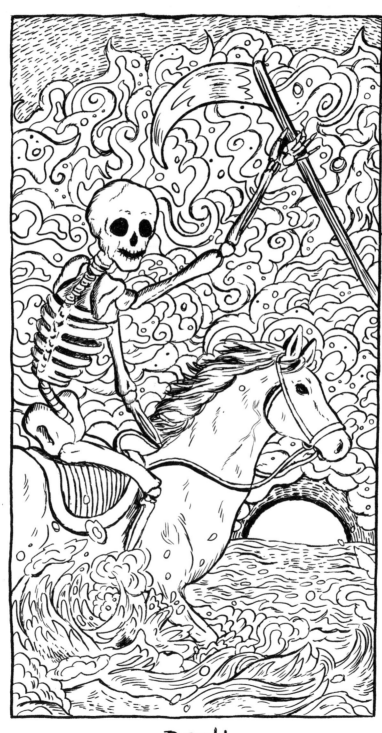

Death

REFLECTIONS

There's time for reflection before this dream is done...

WHAT IS YOUR RELATIONSHIP WITH DEATH?

..

..

..

WHAT IN YOUR LIFE HAD TO END BEFORE SOMETHING NEW COULD START?

..

..

..

DO YOU THINK ANYTHING IN LIFE IS ETERNAL?

..

..

..

WAS THERE A MOMENT IN YOUR LIFE WHEN YOU FELT TRULY REBORN?

..

..

..

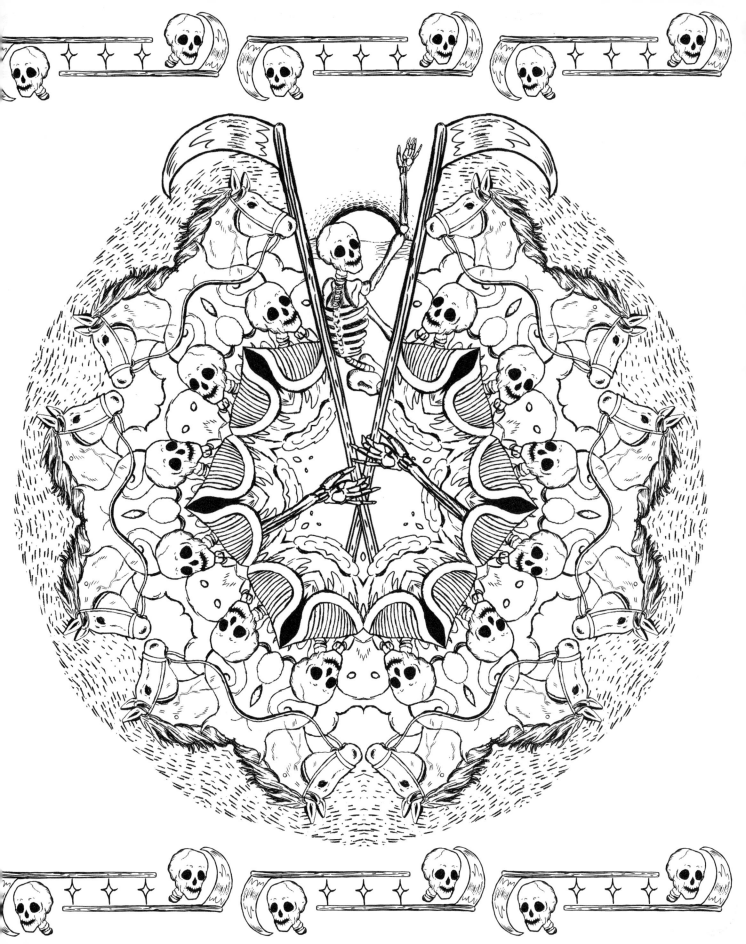

XIV. temperance

A balanced life is a better life.

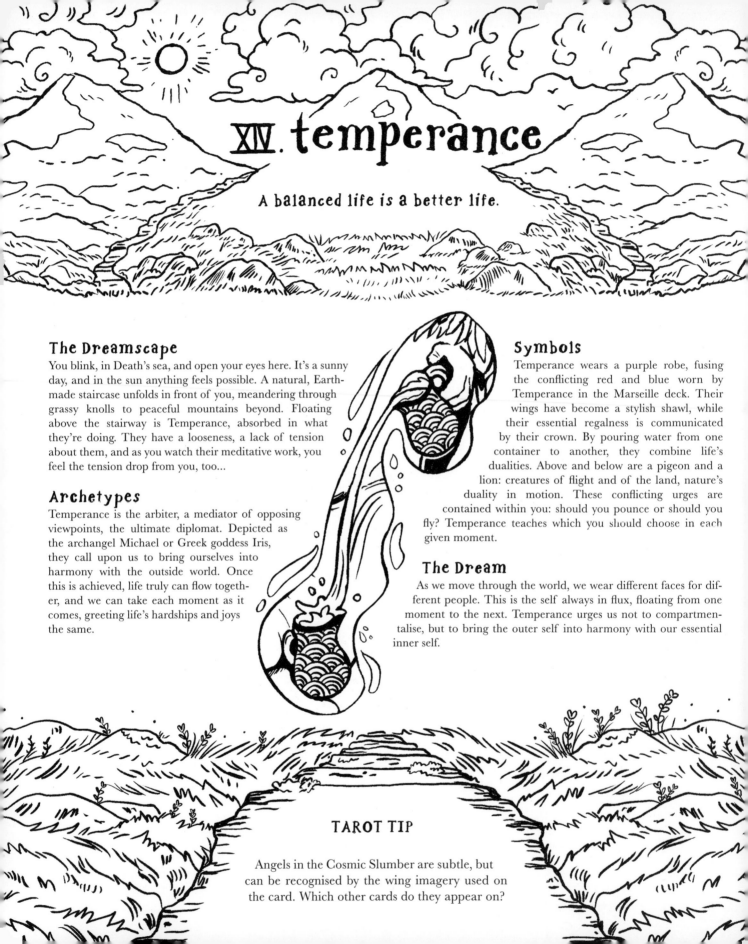

The Dreamscape

You blink, in Death's sea, and open your eyes here. It's a sunny day, and in the sun anything feels possible. A natural, Earth-made staircase unfolds in front of you, meandering through grassy knolls to peaceful mountains beyond. Floating above the stairway is Temperance, absorbed in what they're doing. They have a looseness, a lack of tension about them, and as you watch their meditative work, you feel the tension drop from you, too...

Archetypes

Temperance is the arbiter, a mediator of opposing viewpoints, the ultimate diplomat. Depicted as the archangel Michael or Greek goddess Iris, they call upon us to bring ourselves into harmony with the outside world. Once this is achieved, life truly can flow together, and we can take each moment as it comes, greeting life's hardships and joys the same.

Symbols

Temperance wears a purple robe, fusing the conflicting red and blue worn by Temperance in the Marseille deck. Their wings have become a stylish shawl, while their essential regalness is communicated by their crown. By pouring water from one container to another, they combine life's dualities. Above and below are a pigeon and a lion: creatures of flight and of the land, nature's duality in motion. These conflicting urges are contained within you: should you pounce or should you fly? Temperance teaches which you should choose in each given moment.

The Dream

As we move through the world, we wear different faces for different people. This is the self always in flux, floating from one moment to the next. Temperance urges us not to compartmentalise, but to bring the outer self into harmony with our essential inner self.

TAROT TIP

Angels in the Cosmic Slumber are subtle, but can be recognised by the wing imagery used on the card. Which other cards do they appear on?

COLOR CODE

Light green, olive, green, mauve,
purple, gray, yellow, orange,
aubergine, blue, cream, peach.

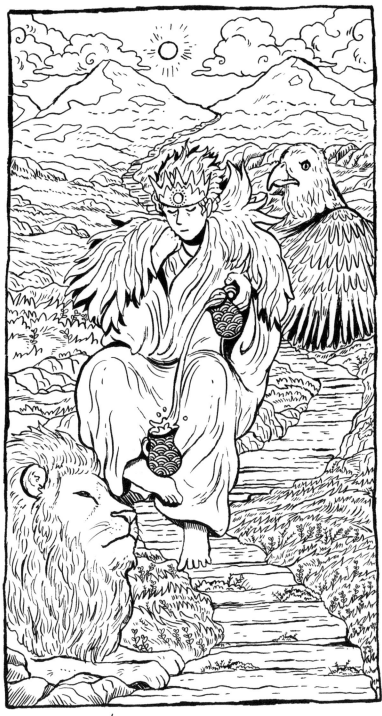

temperance

REFLECTIONS

The outer and inner worlds don't have to be in conflict...

WHAT PARTS OF YOUR LIFE DO YOU NEED TO BRING INTO BALANCE?

..

..

..

DO YOU SOMETIMES FEEL LIKE YOU BECOME DIFFERENT PEOPLE IN DIFFERENT SITUATIONS?

..

..

..

IS THERE A SITUATION YOU WISH YOU'D REACTED DIFFERENTLY TO? HOW WOULD YOU REACT TO IT NOW YOU'VE HAD SOME DISTANCE?

..

..

..

HOW DO CONFLICTS OF MIND MANIFEST IN YOUR DREAMS?

..

..

..

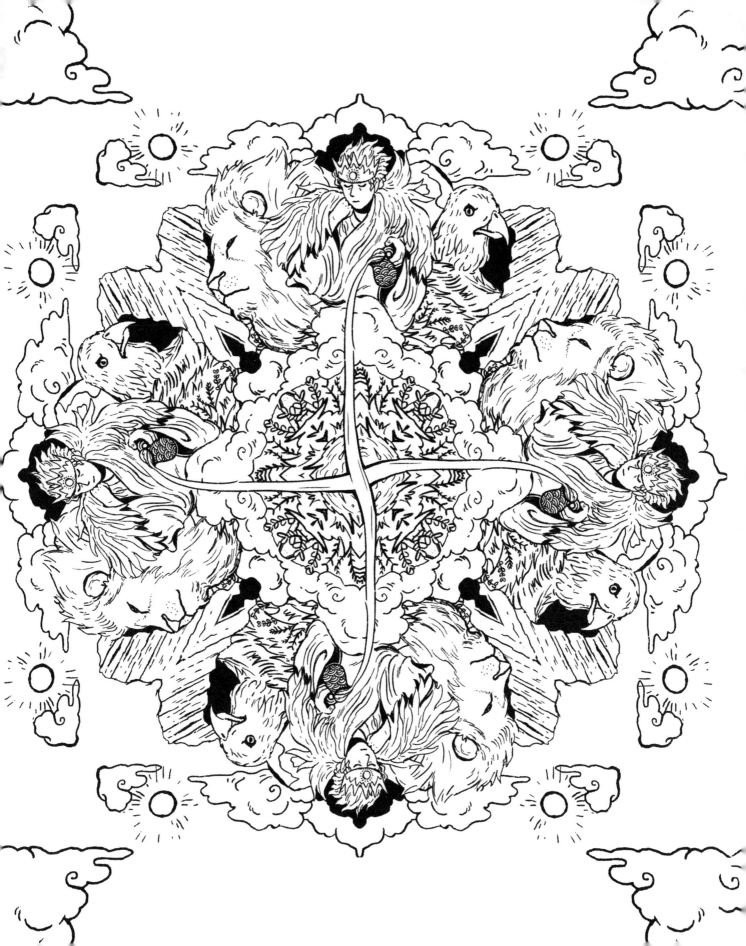

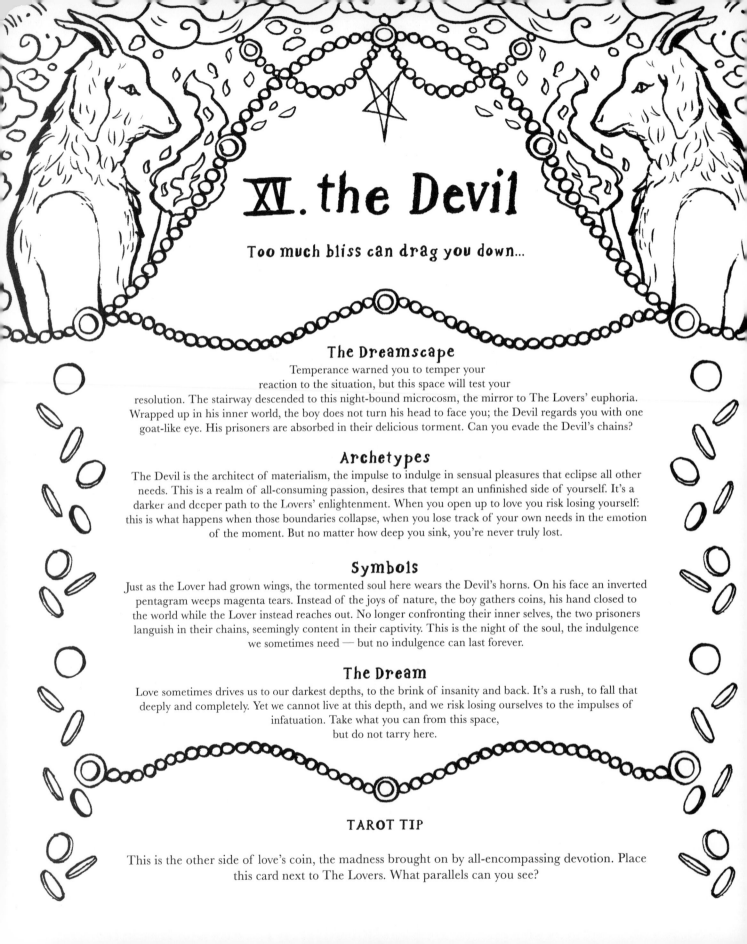

XV. the Devil

Too much bliss can drag you down...

The Dreamscape

Temperance warned you to temper your
reaction to the situation, but this space will test your
resolution. The stairway descended to this night-bound microcosm, the mirror to The Lovers' euphoria.
Wrapped up in his inner world, the boy does not turn his head to face you; the Devil regards you with one
goat-like eye. His prisoners are absorbed in their delicious torment. Can you evade the Devil's chains?

Archetypes

The Devil is the architect of materialism, the impulse to indulge in sensual pleasures that eclipse all other
needs. This is a realm of all-consuming passion, desires that tempt an unfinished side of yourself. It's a
darker and deeper path to the Lovers' enlightenment. When you open up to love you risk losing yourself:
this is what happens when those boundaries collapse, when you lose track of your own needs in the emotion
of the moment. But no matter how deep you sink, you're never truly lost.

Symbols

Just as the Lover had grown wings, the tormented soul here wears the Devil's horns. On his face an inverted
pentagram weeps magenta tears. Instead of the joys of nature, the boy gathers coins, his hand closed to
the world while the Lover instead reaches out. No longer confronting their inner selves, the two prisoners
languish in their chains, seemingly content in their captivity. This is the night of the soul, the indulgence
we sometimes need — but no indulgence can last forever.

The Dream

Love sometimes drives us to our darkest depths, to the brink of insanity and back. It's a rush, to fall that
deeply and completely. Yet we cannot live at this depth, and we risk losing ourselves to the impulses of
infatuation. Take what you can from this space,
but do not tarry here.

TAROT TIP

This is the other side of love's coin, the madness brought on by all-encompassing devotion. Place
this card next to The Lovers. What parallels can you see?

COLOR CODE

Crimson, magenta, pink, peach, cream,
aubergine, purple, dark gray, ice blue,
gray, light green, orange, gold.

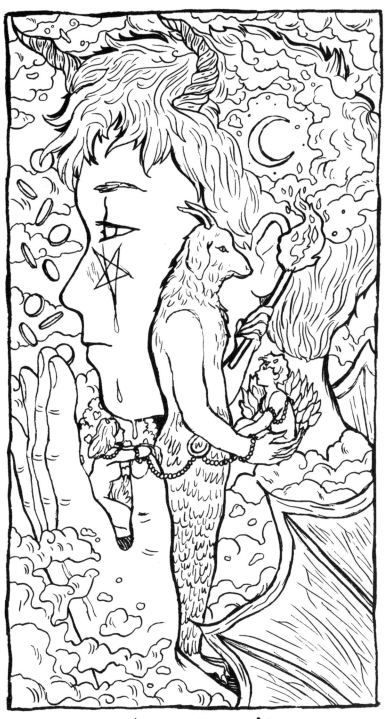

the Devil

REFLECTIONS

Infatuation tests our limits— but there's always something we can learn.

HAVE YOU EVER MET SOMEONE YOU WOULD GO TO HELL AND BACK FOR?

..

..

..

..

..

HAVE YOU EVER FALLEN SO HARD YOU LOST YOURSELF? HOW DID YOU GET YOURSELF BACK?

..

..

..

..

..

DO YOU HAVE A ROUTINE TO HEAL
YOURSELF FROM HEARTBREAK?

..

..

..

..

..

WHAT HAS HEARTBREAK TAUGHT YOU
ABOUT YOURSELF?

..

..

..

..

..

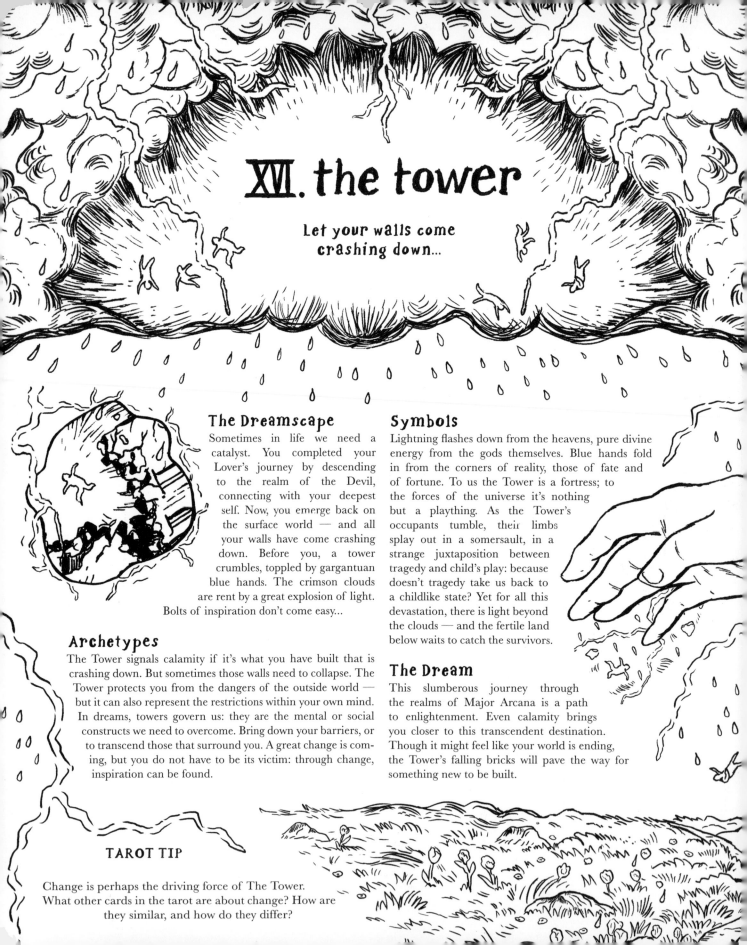

XVI. the tower

Let your walls come crashing down...

The Dreamscape

Sometimes in life we need a catalyst. You completed your Lover's journey by descending to the realm of the Devil, connecting with your deepest self. Now, you emerge back on the surface world — and all your walls have come crashing down. Before you, a tower crumbles, toppled by gargantuan blue hands. The crimson clouds are rent by a great explosion of light. Bolts of inspiration don't come easy...

Archetypes

The Tower signals calamity if it's what you have built that is crashing down. But sometimes those walls need to collapse. The Tower protects you from the dangers of the outside world — but it can also represent the restrictions within your own mind. In dreams, towers govern us: they are the mental or social constructs we need to overcome. Bring down your barriers, or to transcend those that surround you. A great change is coming, but you do not have to be its victim: through change, inspiration can be found.

Symbols

Lightning flashes down from the heavens, pure divine energy from the gods themselves. Blue hands fold in from the corners of reality, those of fate and of fortune. To us the Tower is a fortress; to the forces of the universe it's nothing but a plaything. As the Tower's occupants tumble, their limbs splay out in a somersault, in a strange juxtaposition between tragedy and child's play: because doesn't tragedy take us back to a childlike state? Yet for all this devastation, there is light beyond the clouds — and the fertile land below waits to catch the survivors.

The Dream

This slumberous journey through the realms of Major Arcana is a path to enlightenment. Even calamity brings you closer to this transcendent destination. Though it might feel like your world is ending, the Tower's falling bricks will pave the way for something new to be built.

TAROT TIP

Change is perhaps the driving force of The Tower. What other cards in the tarot are about change? How are they similar, and how do they differ?

COLOR CODE

Magenta, crimson, pink, aubergine, purple, ice blue, yellow, gold, orange, teal, green, navy blue.

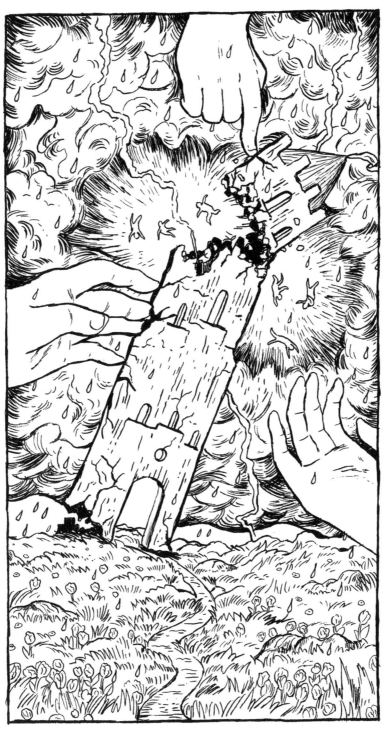

the tower

REFLECTIONS

That which challenges us uniquely forces us into new spaces...

WHAT MENTAL OR SOCIAL CONSTRUCT DO YOU NEED TO OVERCOME?

...
...
...

THINK ABOUT SITUATIONS IN WHICH YOU HAVE FELT INHIBITED SOMEHOW. WHAT PREVENTED YOU FROM ACTING FREELY?

...
...
...

WAS THERE A TIME IN YOUR LIFE WHEN EVERYTHING YOU BUILT CAME CRASHING DOWN? HOW DID THAT CHANGE YOU, AND WHAT DID YOU LEARN FROM THIS?

...
...
...

WHEN WAS THE LAST TIME YOU FELT SO STRUCK BY INSPIRATION THAT THE COURSE OF YOUR LIFE ALTERED, EVEN SLIGHTLY?

...
...
...

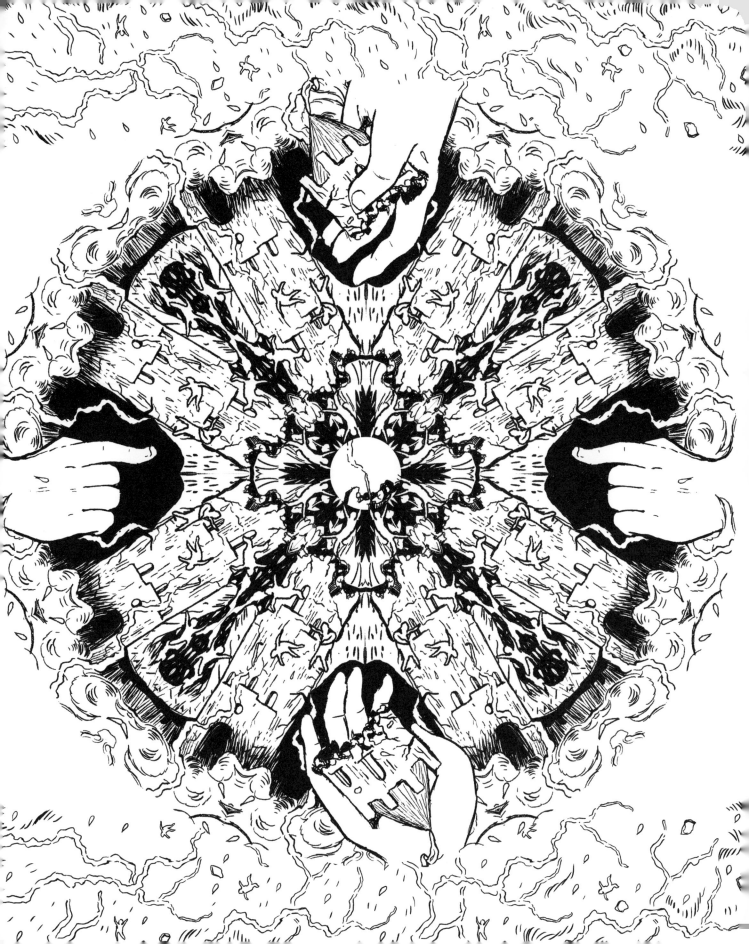

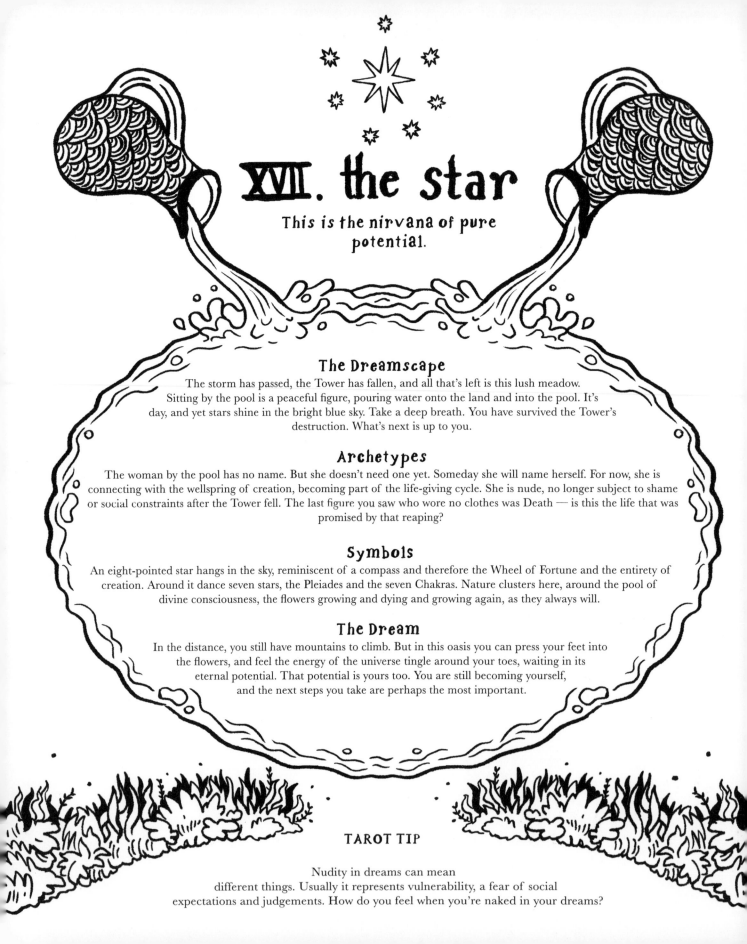

XVII. the star

This is the nirvana of pure potential.

The Dreamscape

The storm has passed, the Tower has fallen, and all that's left is this lush meadow. Sitting by the pool is a peaceful figure, pouring water onto the land and into the pool. It's day, and yet stars shine in the bright blue sky. Take a deep breath. You have survived the Tower's destruction. What's next is up to you.

Archetypes

The woman by the pool has no name. But she doesn't need one yet. Someday she will name herself. For now, she is connecting with the wellspring of creation, becoming part of the life-giving cycle. She is nude, no longer subject to shame or social constraints after the Tower fell. The last figure you saw who wore no clothes was Death — is this the life that was promised by that reaping?

Symbols

An eight-pointed star hangs in the sky, reminiscent of a compass and therefore the Wheel of Fortune and the entirety of creation. Around it dance seven stars, the Pleiades and the seven Chakras. Nature clusters here, around the pool of divine consciousness, the flowers growing and dying and growing again, as they always will.

The Dream

In the distance, you still have mountains to climb. But in this oasis you can press your feet into the flowers, and feel the energy of the universe tingle around your toes, waiting in its eternal potential. That potential is yours too. You are still becoming yourself, and the next steps you take are perhaps the most important.

TAROT TIP

Nudity in dreams can mean different things. Usually it represents vulnerability, a fear of social expectations and judgements. How do you feel when you're naked in your dreams?

COLOR CODE

Blue, yellow, gold, peach, navy blue, ice blue, light green, green, pink, purple.

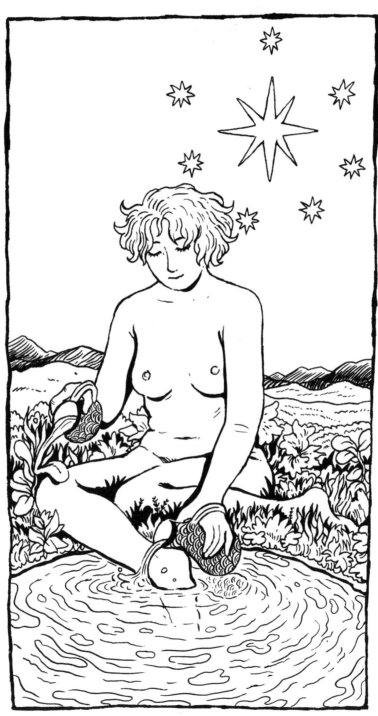

the star

REFLECTIONS

The path ahead is clear...

WHAT ACHIEVEMENTS ARE YOU MOST PROUD OF SO FAR?

..

..

..

WHAT DO YOU STILL WANT TO ACHIEVE?

..

..

..

FIND YOURSELF A GARDEN, OR POUR A BOWL OF WATER AND
LIGHT A CANDLE. CONNECT WITH THAT UNIVERSE OF POTENTIAL.
WRITE THE FIRST THREE THINGS THAT COME TO MIND HERE:

..

..

..

WHAT IN LIFE MAKES YOU GLAD YOU'RE ALIVE?

..

..

..

DIY MANDALA!

The Star is a card of infinite creative potential — so we've left you some room to put your stamp on this mandala.
Think of what brings you joy, and all the ways you like to create...

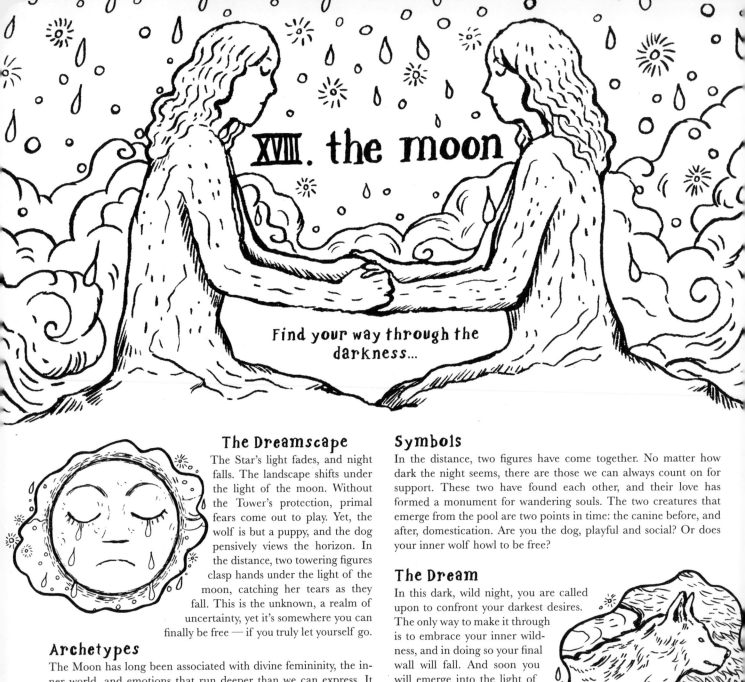

XVIII. the moon

Find your way through the darkness...

The Dreamscape

The Star's light fades, and night falls. The landscape shifts under the light of the moon. Without the Tower's protection, primal fears come out to play. Yet, the wolf is but a puppy, and the dog pensively views the horizon. In the distance, two towering figures clasp hands under the light of the moon, catching her tears as they fall. This is the unknown, a realm of uncertainty, yet it's somewhere you can finally be free — if you truly let yourself go.

Symbols

In the distance, two figures have come together. No matter how dark the night seems, there are those we can always count on for support. These two have found each other, and their love has formed a monument for wandering souls. The two creatures that emerge from the pool are two points in time: the canine before, and after, domestication. Are you the dog, playful and social? Or does your inner wolf howl to be free?

The Dream

In this dark, wild night, you are called upon to confront your darkest desires. The only way to make it through is to embrace your inner wildness, and in doing so your final wall will fall. And soon you will emerge into the light of the Sun...

Archetypes

The Moon has long been associated with divine femininity, the inner world, and emotions that run deeper than we can express. It pulls you like the tide, ever forward into a dark land where illusions are impossible to tell from truths. Yet the Moon is also healing, and as the ruler of the night she also rules your dreams. Look upon her kindly, be honest to your deepest self, and you will find your way in this strange land.

TAROT TIP

The tears dripping from the Moon echo the watery theme of this card but also create a deep sense of melancholy. How does this connect to its nocturnal nature?

COLOR CODE

Magenta, aubergine, purple, olive, brown, mauve, ice blue, light gray, gold, peach.

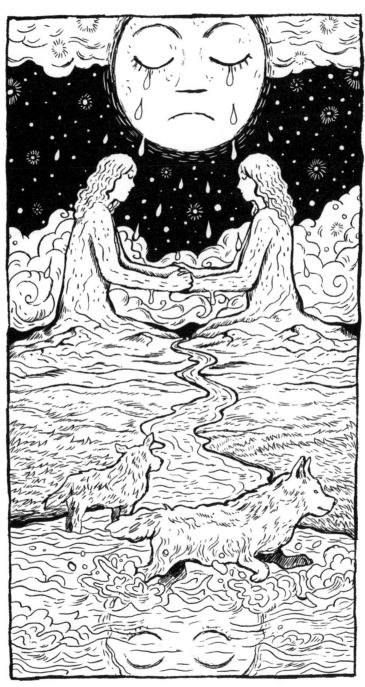

the moon

REFLECTIONS

This is a path you must walk, but it will not take forever.

HAVE YOU EVER HAD A DREAM WHERE YOU WERE WANDERING
AROUND AT NIGHT? WHERE DID YOU END UP?

..

..

..

HAS A FRIEND EVER HELPED YOU THROUGH A TOUGH TIME?
WHAT DID THIS EXPERIENCE TEACH YOU?

..

..

..

HOW DO YOU FIND YOUR WAY WHEN YOU FEEL LOST?

..

..

..

DO YOU FEEL MORE COMFORTABLE AT NIGHT OR DURING THE DAY?

..

..

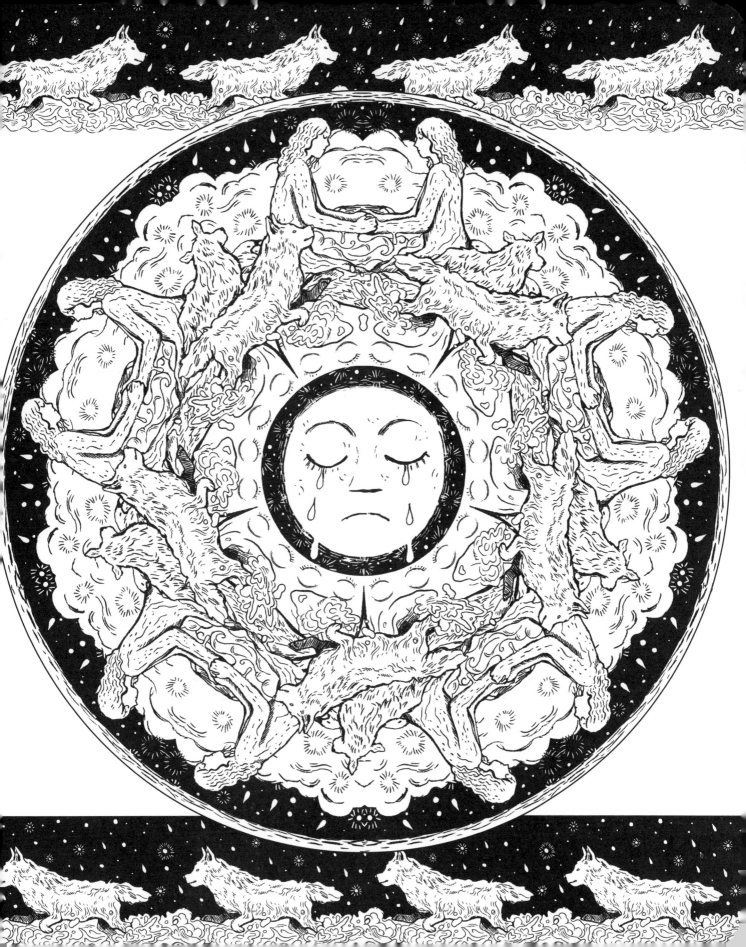

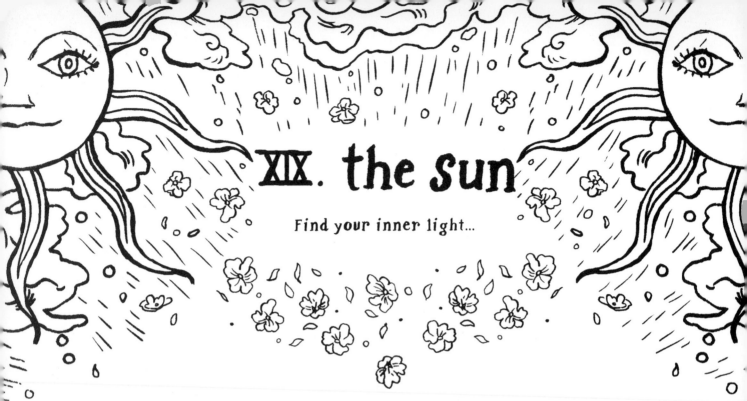

XIX. the sun

Find your inner light...

The Dreamscape

You've emerged from darkness into light — and now anything is possible. Ahead of you is a reflection of yourself, a figure embracing their inner light. This sun shines right into your soul, bathing you in warmth. In the face of this pure joy, you can feel everything else melt away. Below, in an untamed garden, children play. Sometimes, everything really does turn out alright.

Archetypes

The Sun is the ultimate symbol of light and life in the universe. Without it, we could not live, and in the light of the sun even tragedy doesn't seem so bad. The Sun is adventure, new life, the burning centerpoint that we all orbit around. This light shines within you, too, even if sometimes the dark around you seems to blot it out.

Symbols

The figure clasps the Sun to their chest, an expression of blissful self-love. This is how it feels to cherish everything about yourself that you're proud of: what you've become, how you've healed, what you've always been. Below, the children are caught up in the pure joy of life itself. And there is no greater thing in this world than to be alive.

The Dream

You've journeyed far to get to this place. It hasn't been easy, and in this dream you've seen things you could scarcely imagine. You've scaled mountains, spoken with giants and ancient gods, unlocked mysteries and confronted your deepest self. There are still miles to go, but now you can embrace everything life can be — and everything you are.

TAROT TIP

The Moon's eyes were closed, while the Sun's are open. We're nearing the end of the dream now, and your lucidity is growing. Can you guide yourself to waking?

COLOR CODE

Magenta, peach, gold, brown, olive,
light green, orange, aubergine,
purple, gray, cream.

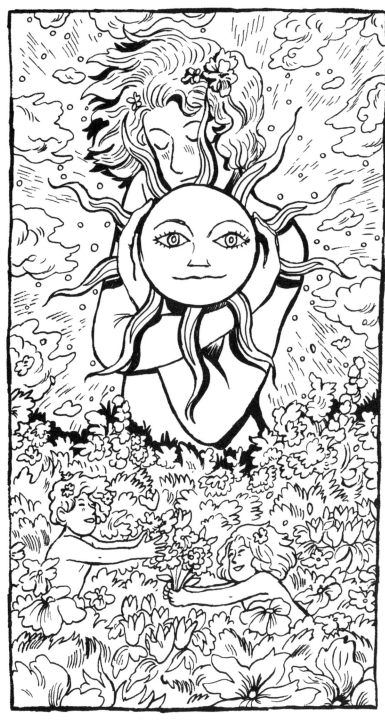

the sun

REFLECTIONS

At the end of the day, the best friend you'll ever have is yourself.

WHAT DO YOU LIKE BEST ABOUT YOURSELF?

..
..
..
..
..
..

WHAT IN LIFE BRINGS YOU THE GREATEST JOY?

..
..
..
..
..
..

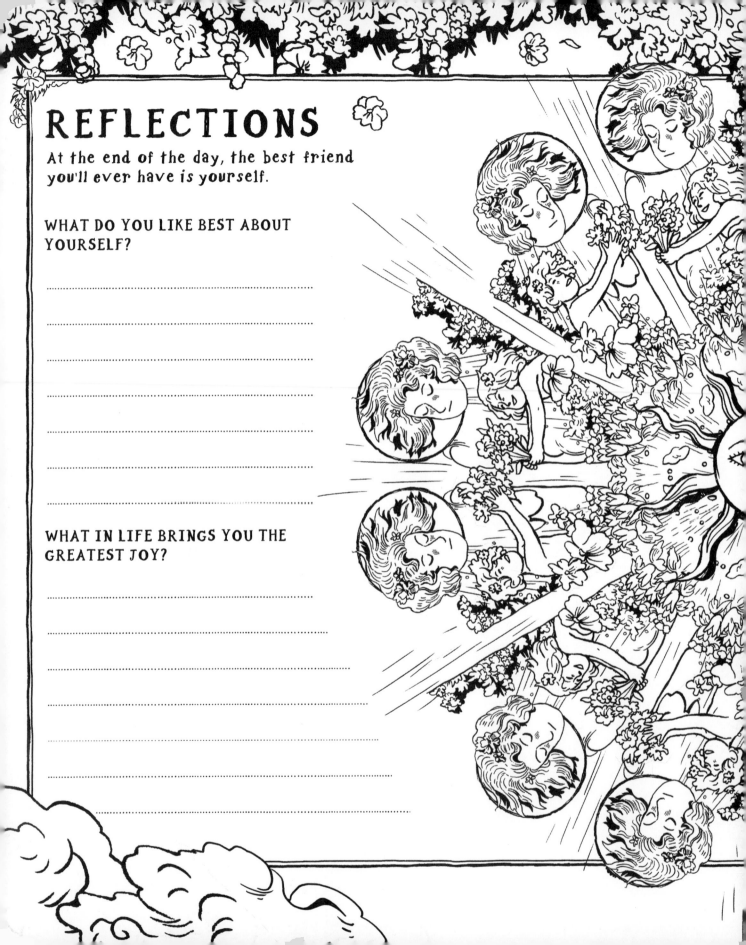

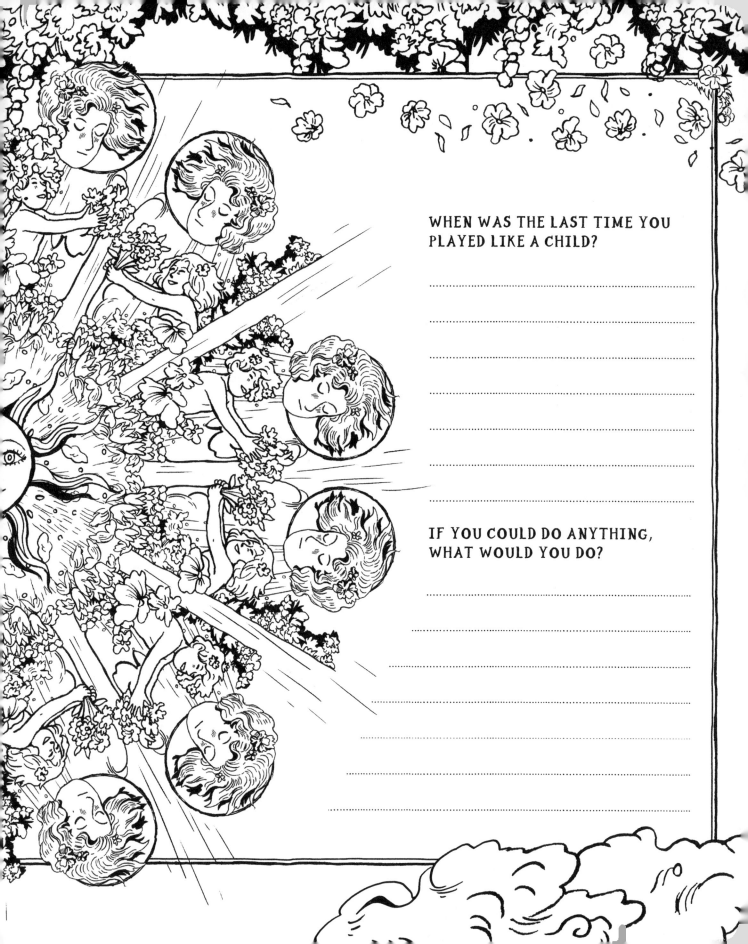

WHEN WAS THE LAST TIME YOU
PLAYED LIKE A CHILD?

..
..
..
..
..
..

IF YOU COULD DO ANYTHING,
WHAT WOULD YOU DO?

..
..
..
..
..
..

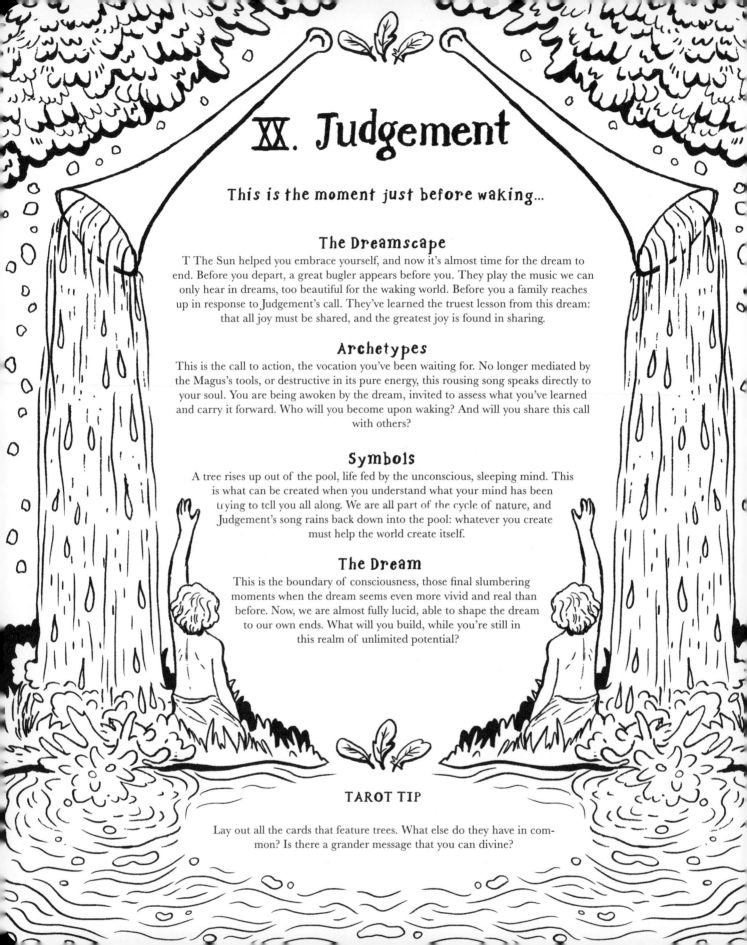

XX. Judgement

This is the moment just before waking...

The Dreamscape

T The Sun helped you embrace yourself, and now it's almost time for the dream to end. Before you depart, a great bugler appears before you. They play the music we can only hear in dreams, too beautiful for the waking world. Before you a family reaches up in response to Judgement's call. They've learned the truest lesson from this dream: that all joy must be shared, and the greatest joy is found in sharing.

Archetypes

This is the call to action, the vocation you've been waiting for. No longer mediated by the Magus's tools, or destructive in its pure energy, this rousing song speaks directly to your soul. You are being awoken by the dream, invited to assess what you've learned and carry it forward. Who will you become upon waking? And will you share this call with others?

Symbols

A tree rises up out of the pool, life fed by the unconscious, sleeping mind. This is what can be created when you understand what your mind has been trying to tell you all along. We are all part of the cycle of nature, and Judgement's song rains back down into the pool: whatever you create must help the world create itself.

The Dream

This is the boundary of consciousness, those final slumbering moments when the dream seems even more vivid and real than before. Now, we are almost fully lucid, able to shape the dream to our own ends. What will you build, while you're still in this realm of unlimited potential?

TAROT TIP

Lay out all the cards that feature trees. What else do they have in common? Is there a grander message that you can divine?

COLOR CODE

Purple, mauve, aubergine, yellow,
gold, orange, ice blue, light gray,
peach, cream, crimson, salmon.

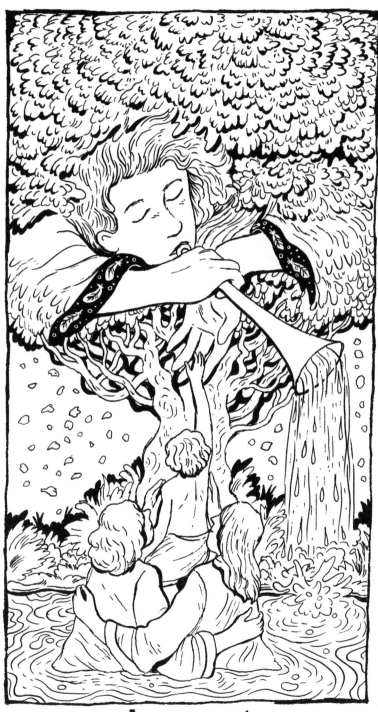

Judgement

REFLECTIONS

The dream clings to you still...

WHAT DID YOU DREAM ABOUT LAST NIGHT?
WHAT DO YOU THINK IT MEANT?

HAVE YOU ALREADY FOUND YOUR TRUE VOCATION?

HOW DO YOU USE YOUR LIFE TO UPLIFT OTHERS?

IF YOU COULD BUILD ANYTHING, WHAT WOULD YOU CREATE?

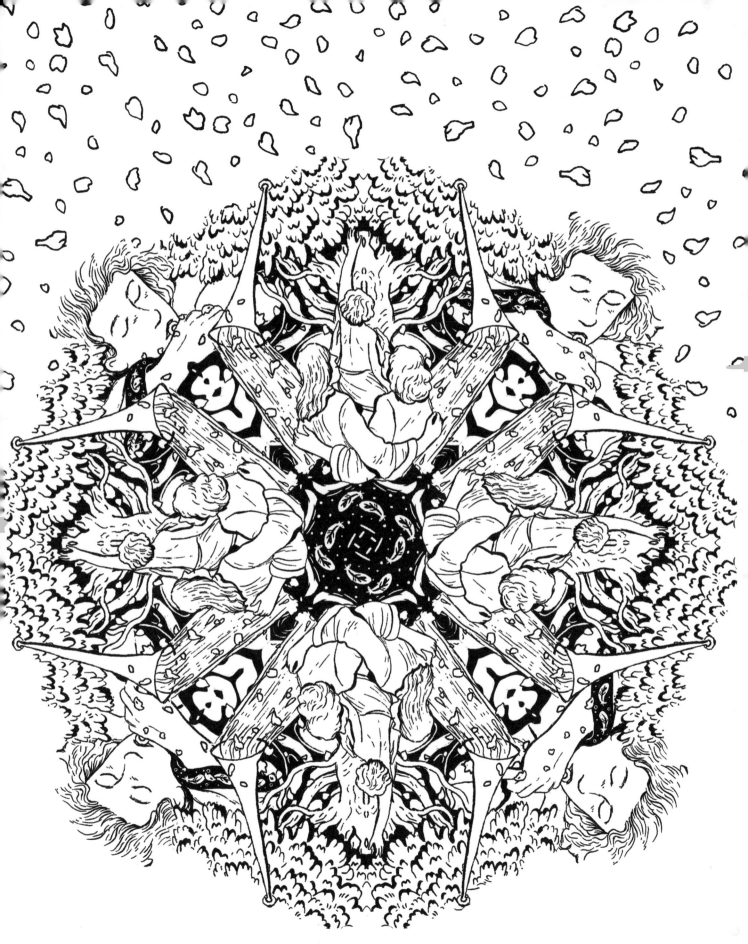

XXI. the universe

It's time to wake up to everything you can be.

The Dreamscape

A swirling rainbow of color leads you out of the dream. This is the moment of waking, that split second when reality and unreality are one, and the universe holds its breath. This dancer is you, caught in the ecstasy of waking and remembering yourself. For this moment, all that is and could be is contained within you. As you open your eyes, you see the sunrise burst, painting the cosmos gold. Today is a good day to be alive.

Archetypes

The Universe card is reality in love with the joy of existence, dancing for pure joy of itself. The dancer is present in the truest sense, simply being. She has transcended all boundaries of mind and materialism, has become indestructible and infinite. Through her dance we are granted a glimpse of eternity. So dance, and learn what only she can teach you.

Symbols

Those living beings are here again, the fixed signs of the Zodiac clustering around the dancer, bringing the four corners of the Earth together again. This is the universe on the head of a pin, indicated by the wands reflected above and below the dancer, completing the circuit of cosmic energy. Vines twist around the dancer's limbs, a reminder that we are always connected to nature, as we are natural beings ourselves.

The Dream

Every day we become ourselves, again and again, and it's the best reminder we have that we're alive. We awake and become part of the universe's great dance: life in love with itself.

TAROT TIP

Have you ever awoken from one dream only to find yourself in another? Moments like these challenge the boundaries between dreaming and waking, making us question where reality lies. Perhaps this Universe is merely a step towards another, greater, dream...

COLOR CODE

Gold, yellow, cream, peach, brown,
crimson, magenta, pink, ice blue,
light green, gray, dark gray, salmon.

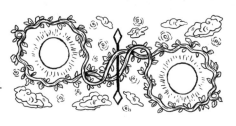

the universe

REFLECTIONS

Open your eyes...

RECORD YOUR FIRST THOUGHTS UPON WAKING HERE:

..

..

..

WHAT HAVE YOU LEARNED FROM THIS JOURNEY?

..

..

..

IN WHAT MOMENTS DO YOU FEEL THE MOST PRESENT?

..

..

..

WHAT IN LIFE JUST MAKES YOU WANT TO DANCE?

..

..

..

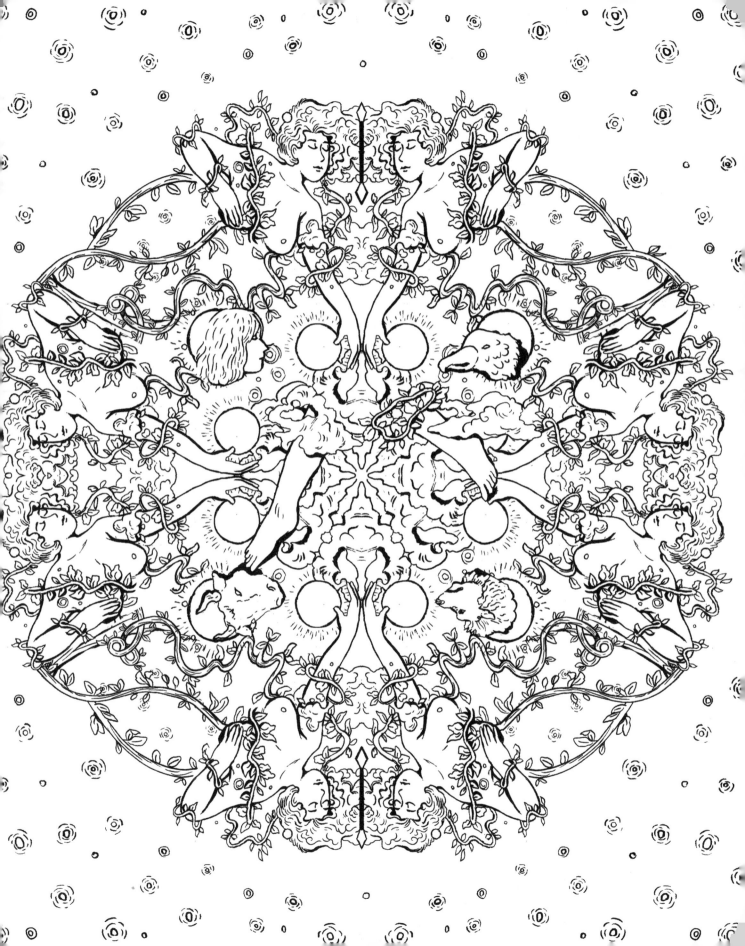

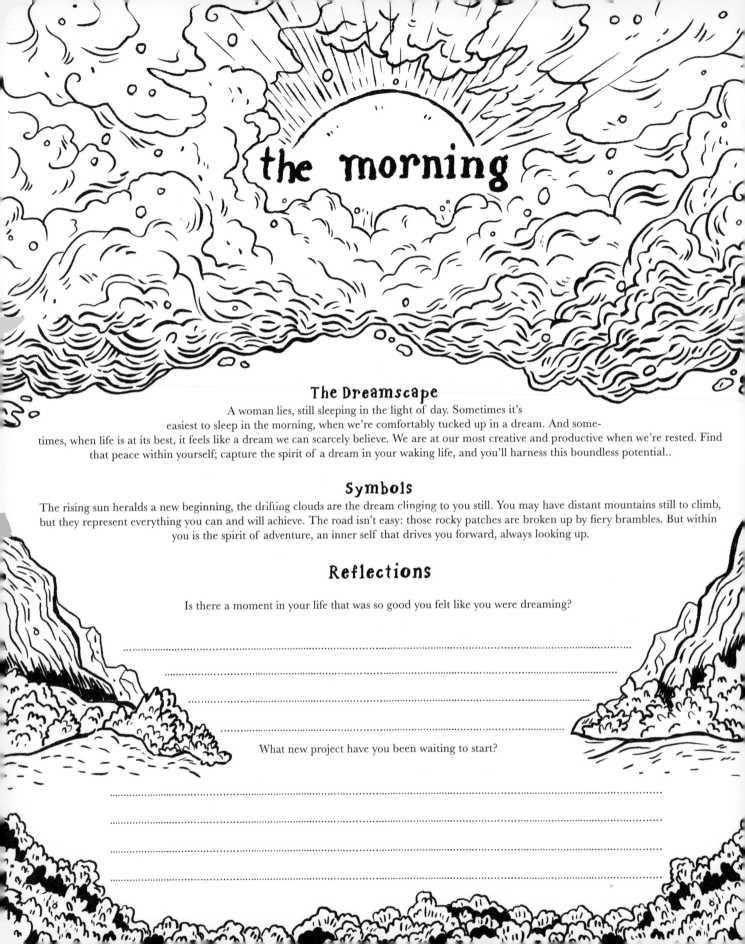

the morning

The Dreamscape

A woman lies, still sleeping in the light of day. Sometimes it's easiest to sleep in the morning, when we're comfortably tucked up in a dream. And sometimes, when life is at its best, it feels like a dream we can scarcely believe. We are at our most creative and productive when we're rested. Find that peace within yourself; capture the spirit of a dream in your waking life, and you'll harness this boundless potential..

Symbols

The rising sun heralds a new beginning, the drifting clouds are the dream clinging to you still. You may have distant mountains still to climb, but they represent everything you can and will achieve. The road isn't easy: those rocky patches are broken up by fiery brambles. But within you is the spirit of adventure, an inner self that drives you forward, always looking up.

Reflections

Is there a moment in your life that was so good you felt like you were dreaming?

...

...

...

What new project have you been waiting to start?

...

...

...

...

COLOR CODE

Crimson, ice blue, salmon, mauve, olive, light green, dark gray, brown, cream, yellow.

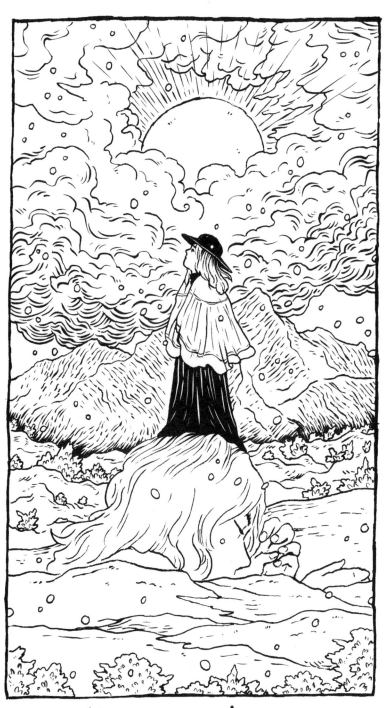

the morning

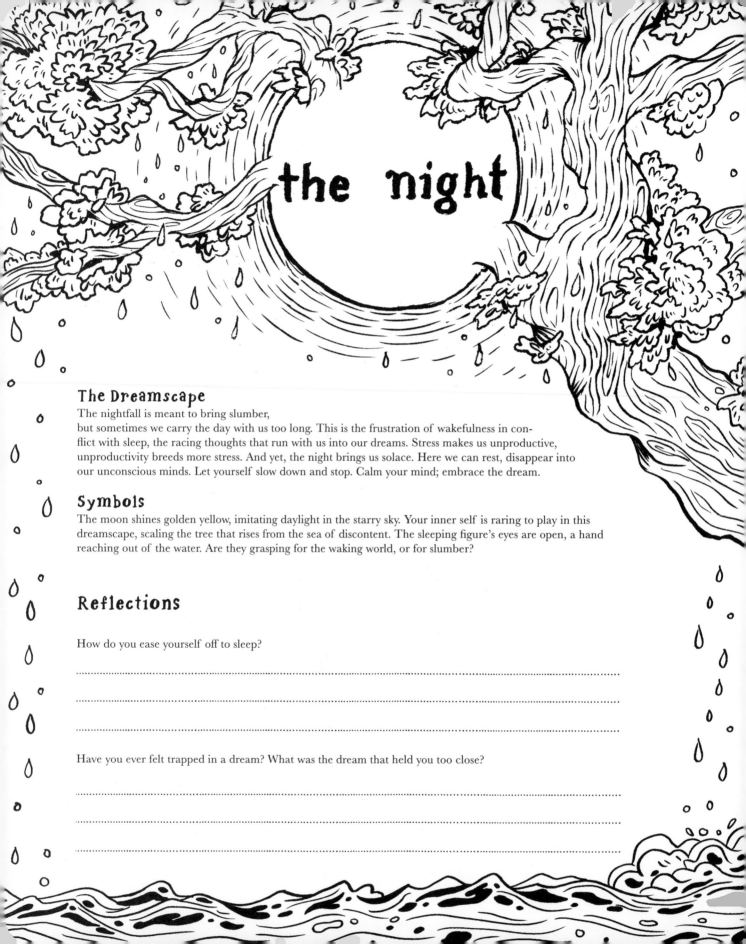

the night

The Dreamscape

The nightfall is meant to bring slumber,
but sometimes we carry the day with us too long. This is the frustration of wakefulness in con-
flict with sleep, the racing thoughts that run with us into our dreams. Stress makes us unproductive,
unproductivity breeds more stress. And yet, the night brings us solace. Here we can rest, disappear into
our unconscious minds. Let yourself slow down and stop. Calm your mind; embrace the dream.

Symbols

The moon shines golden yellow, imitating daylight in the starry sky. Your inner self is raring to play in this
dreamscape, scaling the tree that rises from the sea of discontent. The sleeping figure's eyes are open, a hand
reaching out of the water. Are they grasping for the waking world, or for slumber?

Reflections

How do you ease yourself off to sleep?

..

..

..

Have you ever felt trapped in a dream? What was the dream that held you too close?

..

..

..

COLOR CODE

Pink, peach, salmon, dark gray, yellow, crimson, olive, light green, brown, blue, cream.

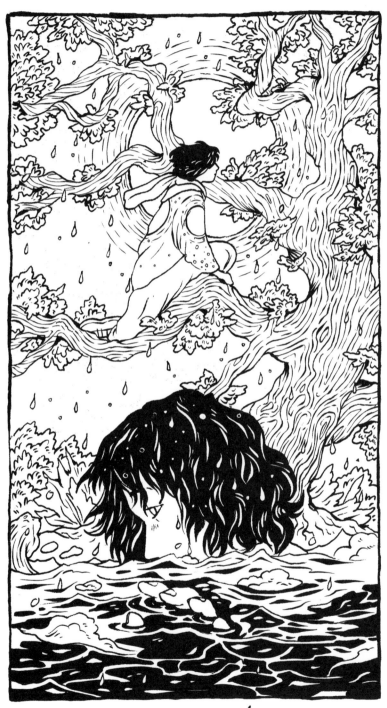

the night

THE MINOR ARCANA

The Majors may have been the great moments of the Cosmic Slumber, the kind of dreams that heighten your awareness and bring with them great revelations. But not every dream is like that.

More often than not, our everyday life plays out in our dreams, albeit in a much more surreal way. The people and places that surround us are reflected in the mind's hall of mirrors. Problems we're trying to resolve play out on the stage of our slumbering imagination, twisting into bizarre stories as the subconscious mind runs scenarios.

In this way, sometimes the most mundane of dreams can be the most enlightening. Like the tarot cards themselves, each dream is a moment in time, connected to the larger narrative of our lives. The Minor Arcana explore the everyday; in the Cosmic Slumber Tarot the Minors take the everyday to the dreaming realm. What new truth can you find here?

NUMBERS

Each number in the Minor Arcana has a special meaning; once you've divined that, you can unlock any card in the four suits…

Ace – Beginnings
Two – Balance
Three – Reaction
Four – Waiting
Five – Difficulty

Six – Inner strength
Seven – Fruition
Eight – Forward Motion
Nine – Reflection
Ten – Completion

Of course, each suit doesn't just have numbered cards…

COURT CARDS

These are the people who greet you in the dream; they are reflections of those who surround you in the waking world.

Pages – The errant youth, just starting out
Knights – Full of action and adventure
Queens – Those who foster others' growth alongside their own
Kings – The authority, wise but still flawed

The Court Cards can also be seen as facets of your own psyche, or the steps you're taking along the journey of the suits. Which do you identify with most in each given suit?

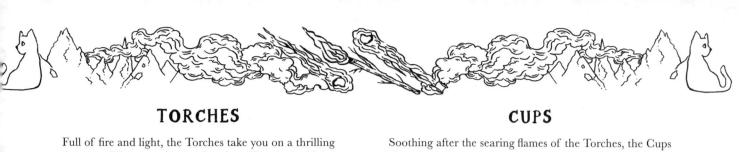

TORCHES

Full of fire and light, the Torches take you on a thrilling adventure. With them in your hand you'll scale the highest peaks, plunge into rocky caverns, and race meteor showers. This is the suit of passion, of willpower, of creativity. But can you keep the spark alight?

REFLECTION

In what area of your life do you find the most passion?

..

..

..

..

CUPS

Soothing after the searing flames of the Torches, the Cups draw from the well of emotion that moves like the tide. In these dreams you are set adrift on your inner sea, as you voyage to distant shores and explore how you connect to yourself and others.

REFLECTION

Do you find it easy to relate to others?

..

..

..

..

SWORDS

Soaring into a crimson sky, the Swords take you to the cosmos and back. This is a realm of limitless imagination, a dream in which you're fighting for your life but you can't remember why. Grasp the sword that is offered to you — your rational mind will guide you through.

REFLECTION

What is your sword: the tool with which you stave off life's hardships?

..

..

..

..

PENTACLES

The Pentacles bring you back down to Earth from the airy Swords. These dreams are all about practicality, responsibility, the seeds we sow and how we reap them. Everything you have worked for, everything you have built, lies before you here.

REFLECTION

Where do you feel the most at home?

..

..

..

..

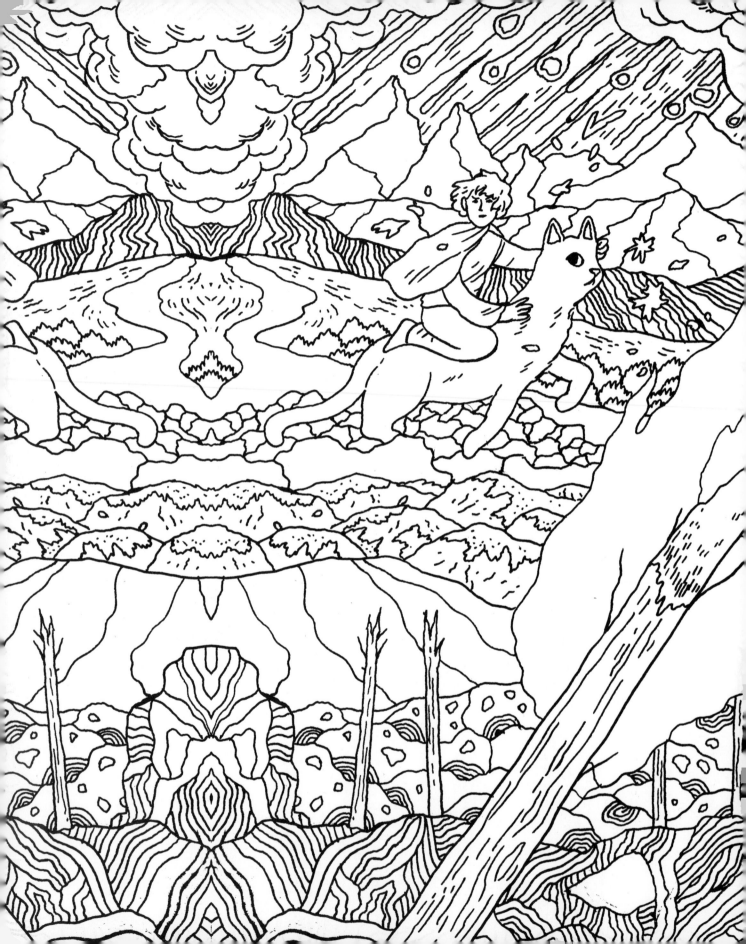

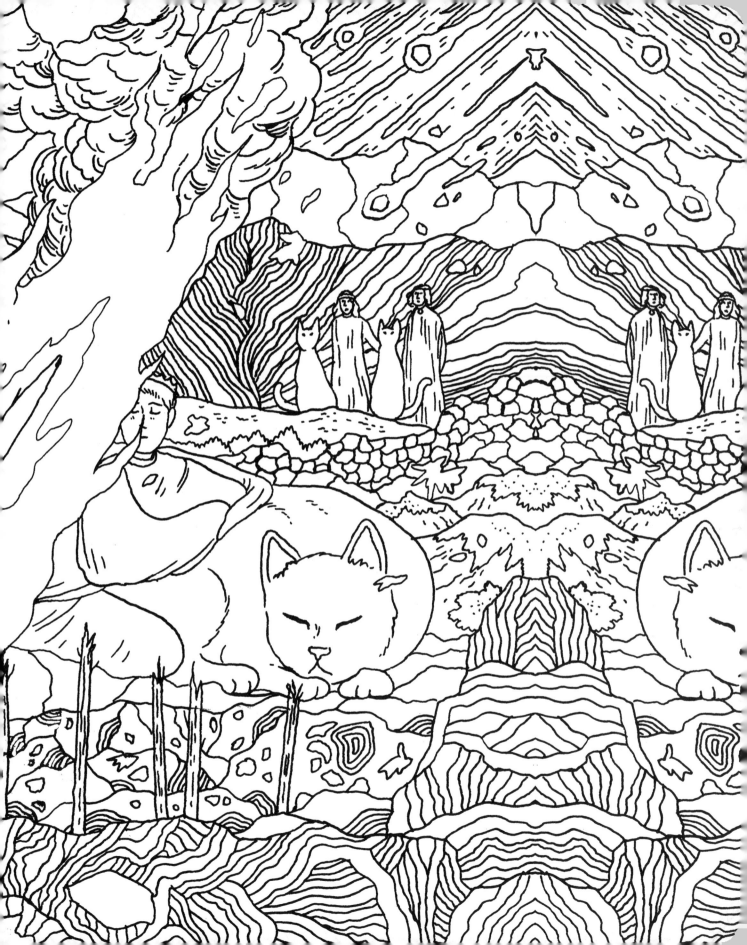

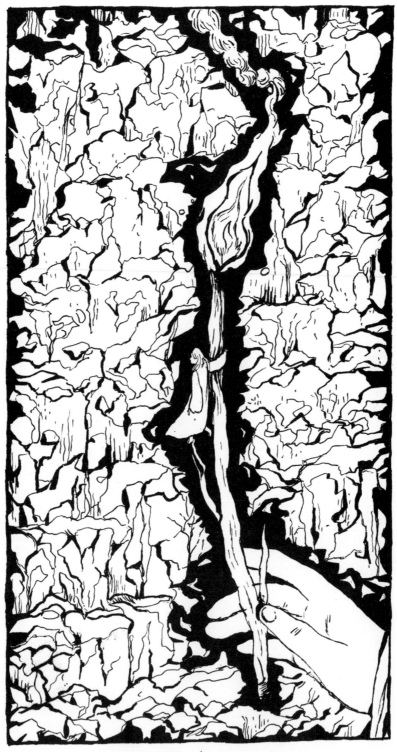

Ace of torches

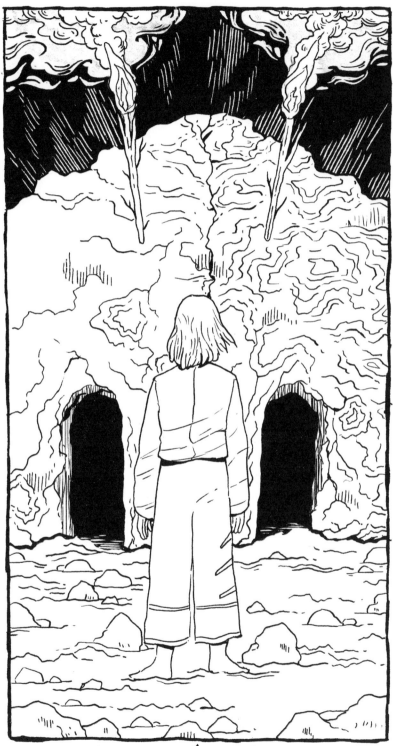

two of torches

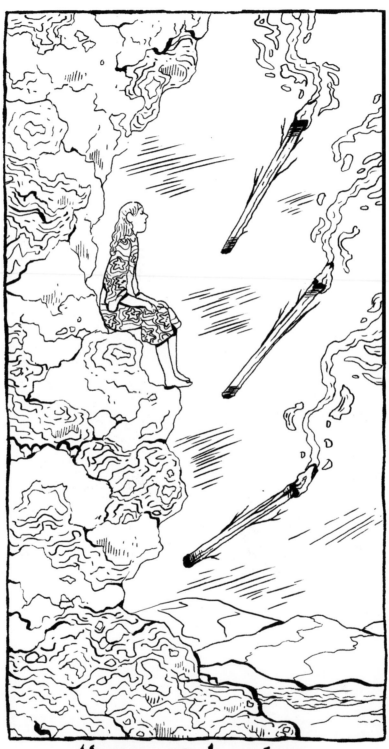

three of torches

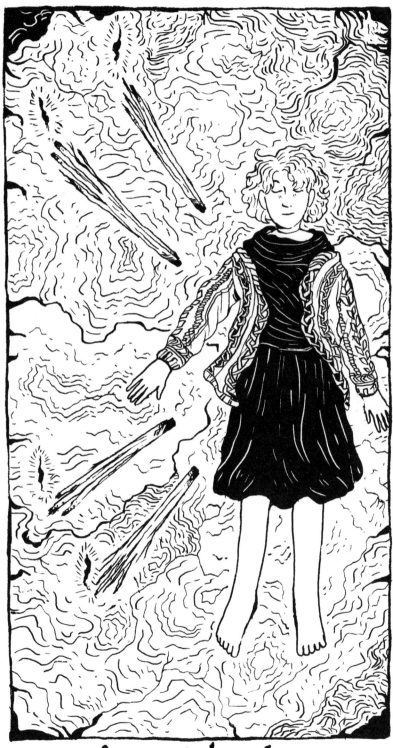

four of torches

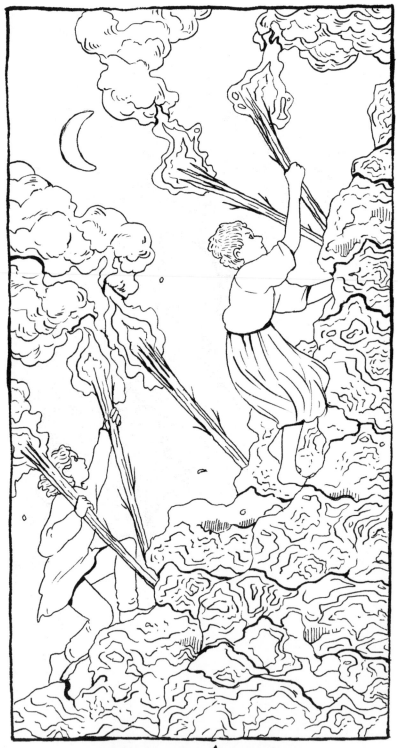

five of torches

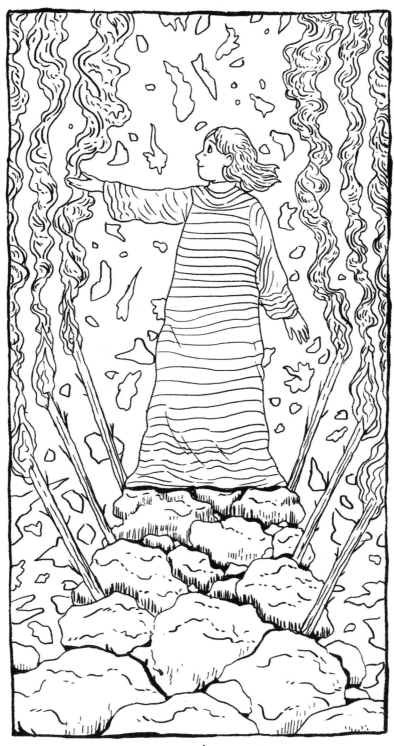

six of torches

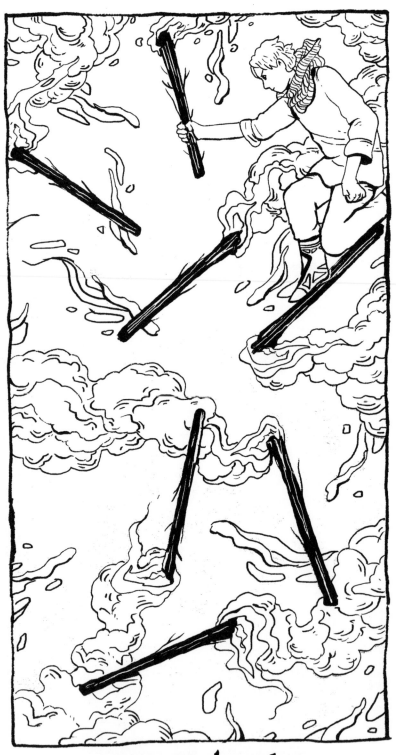

seven of torches

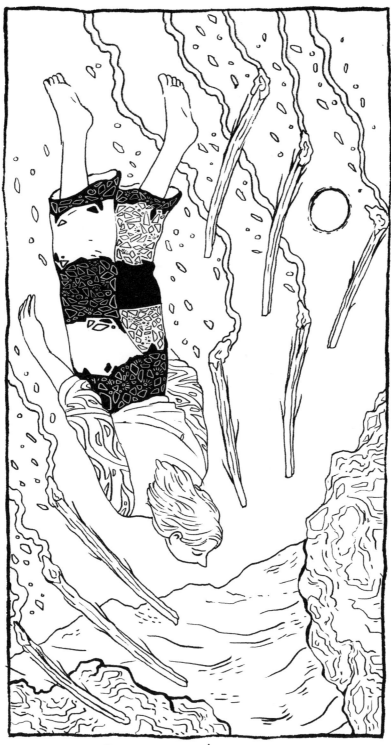

eight of torches

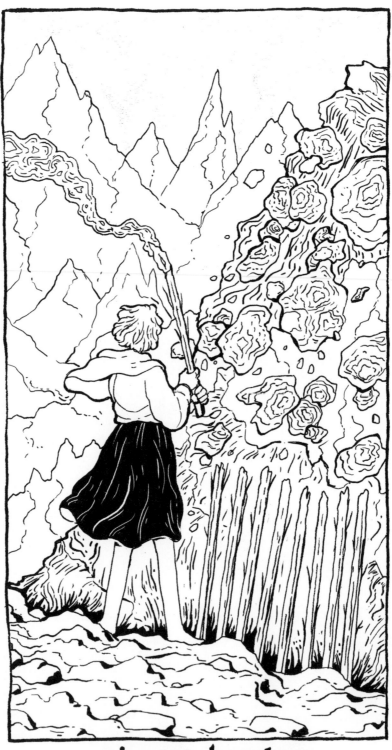

nine of torches

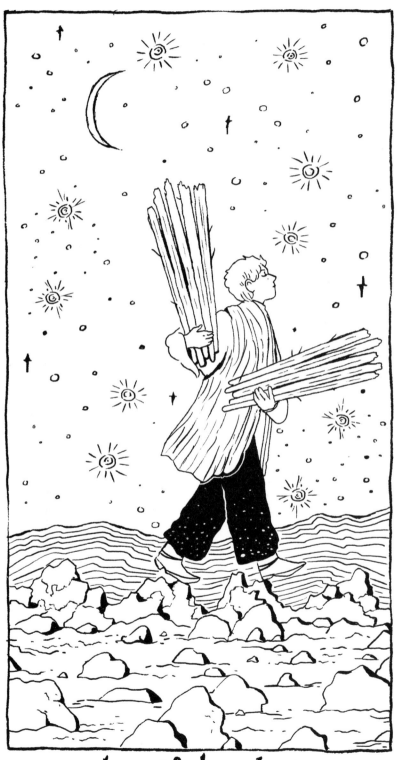

ten of torches

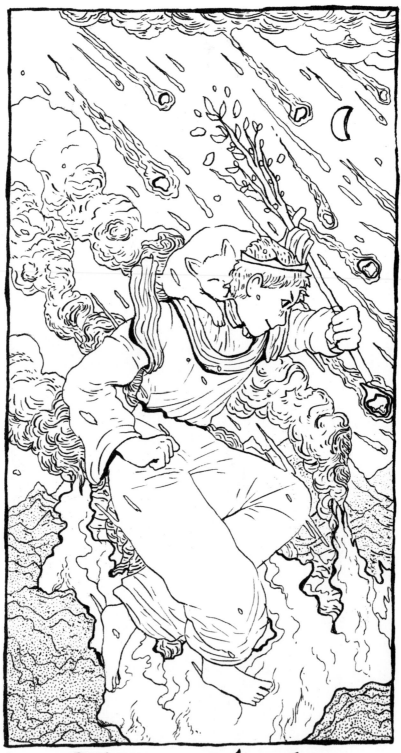

Princess of torches

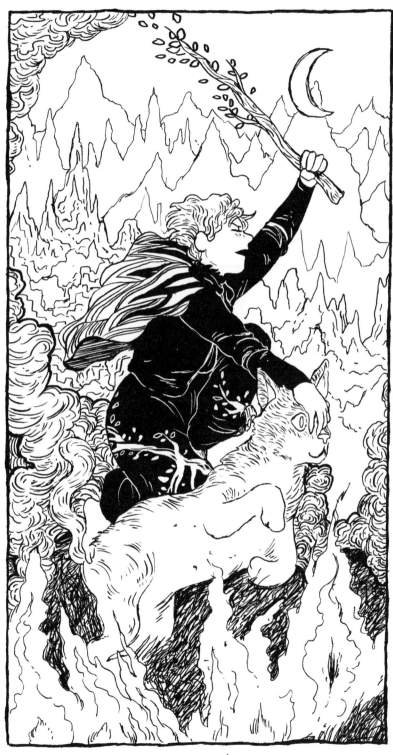

Prince of torches

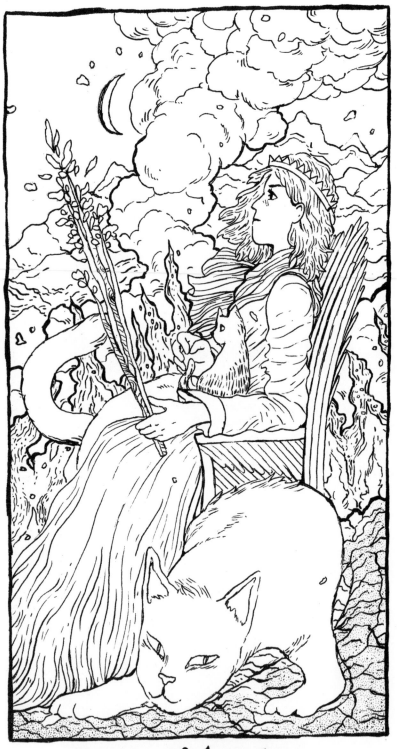

Queen of torches

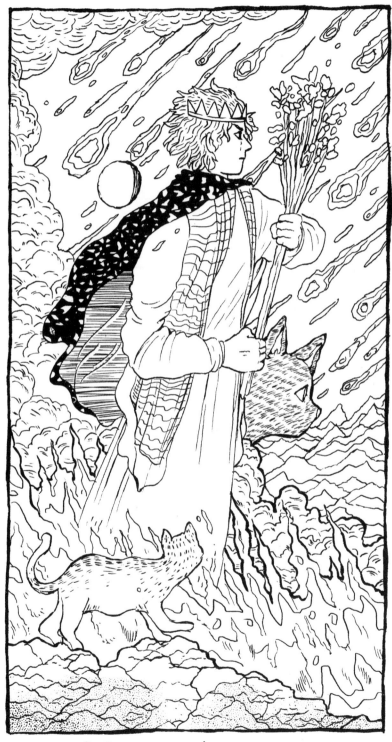

King of torches

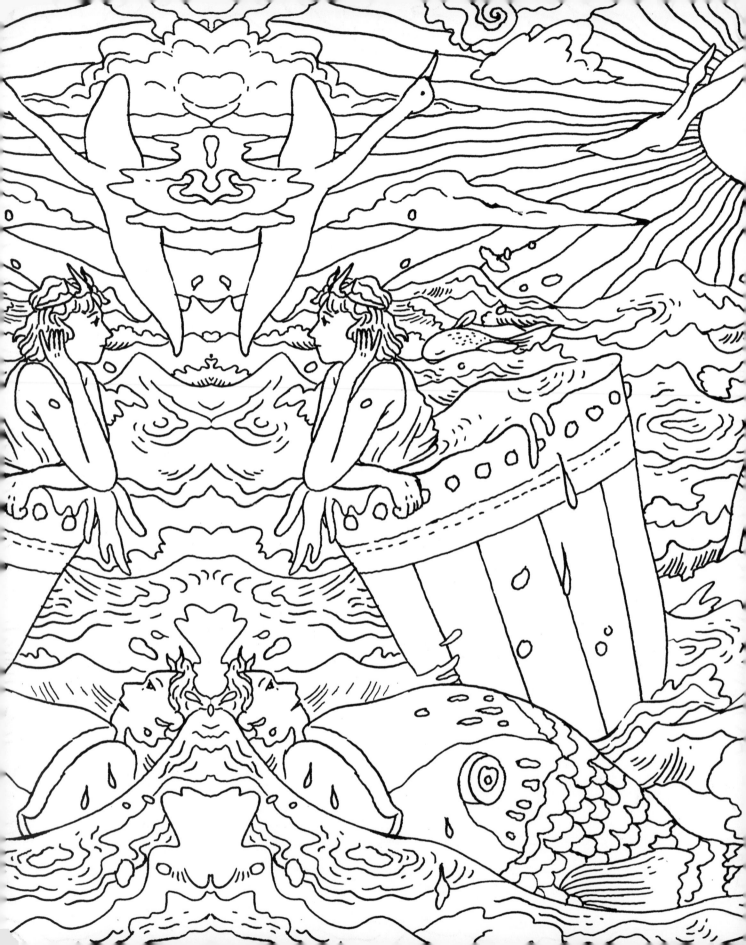

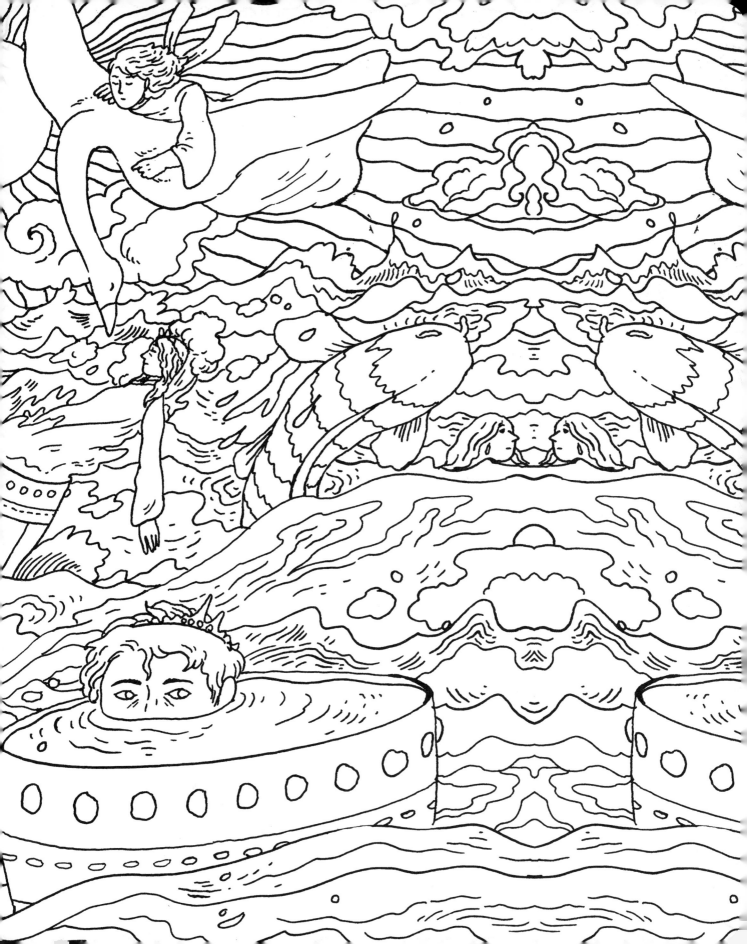

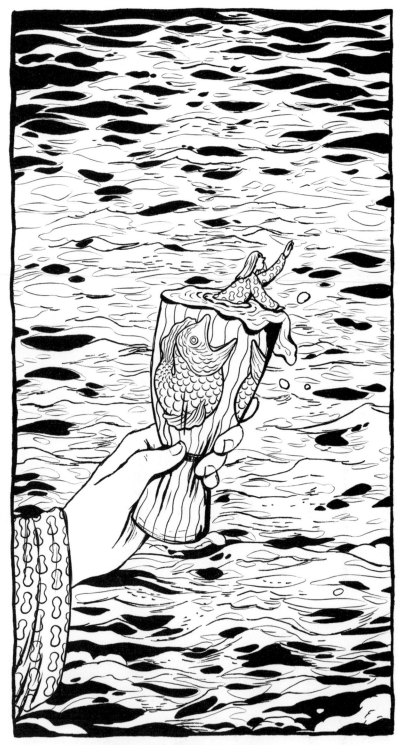

ace of cups

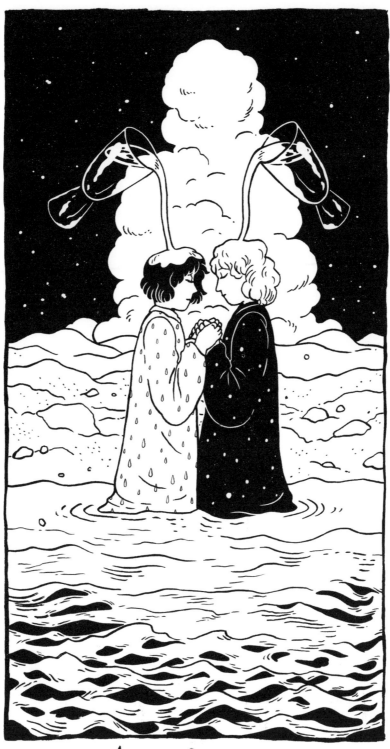

two of cups

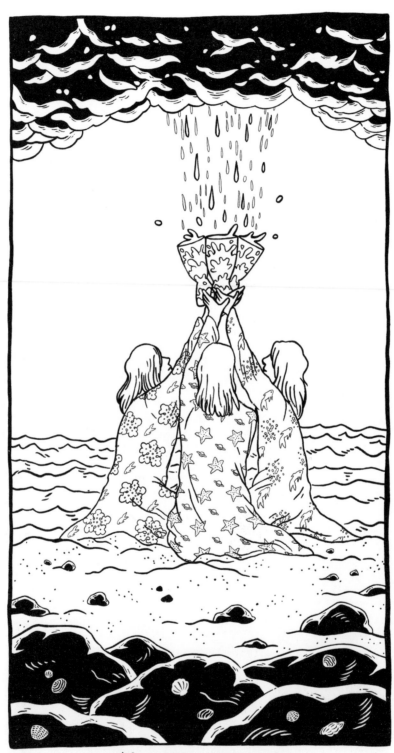

three of cups

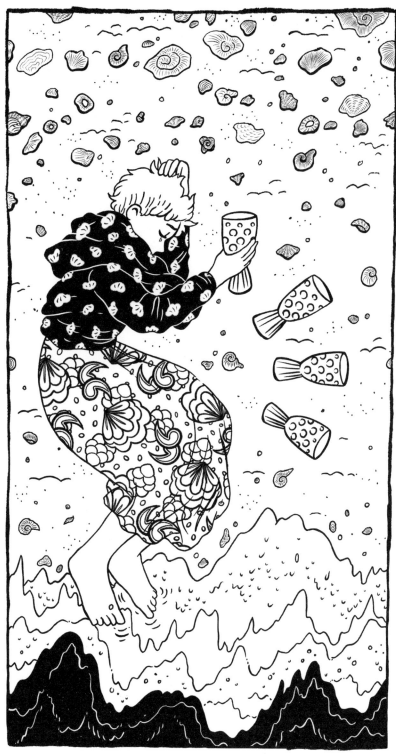

four of cups

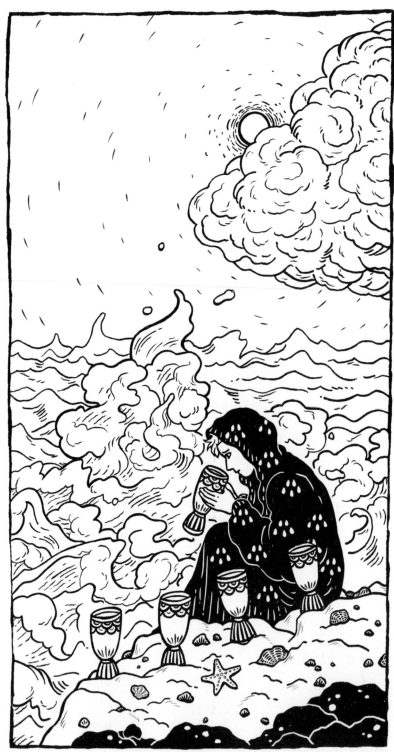

five of cups

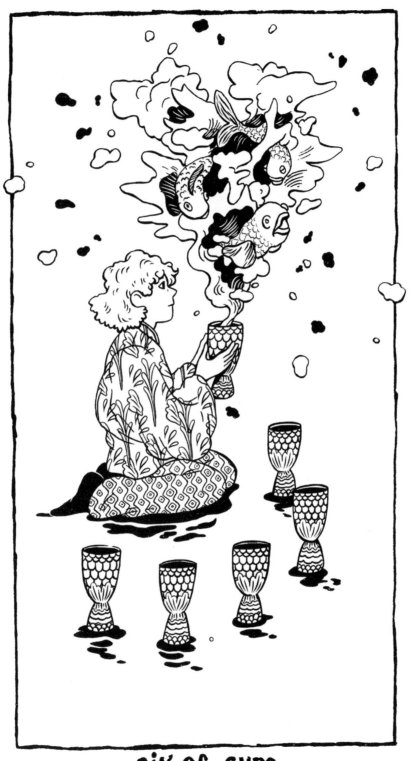

six of cups

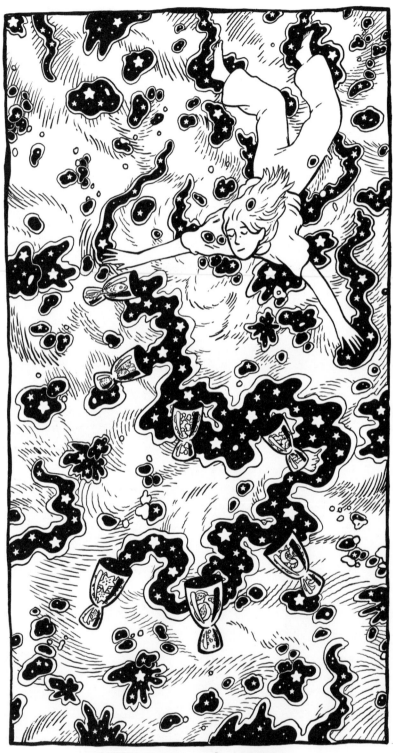

seven of cups

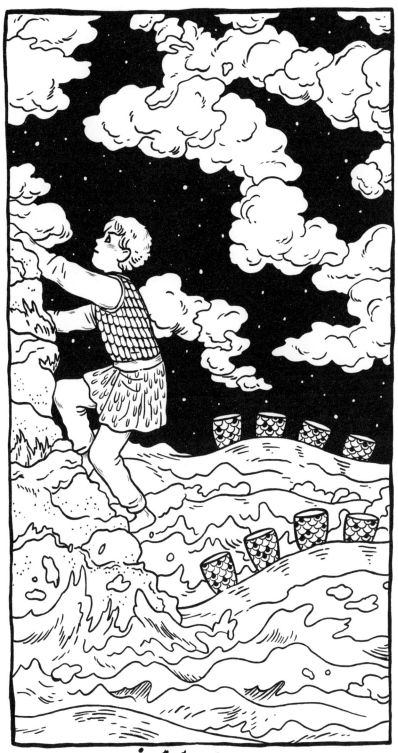

eight of cups

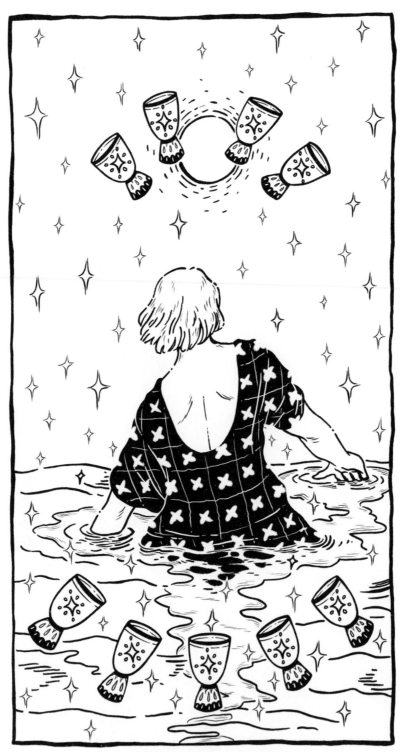

nine of cups

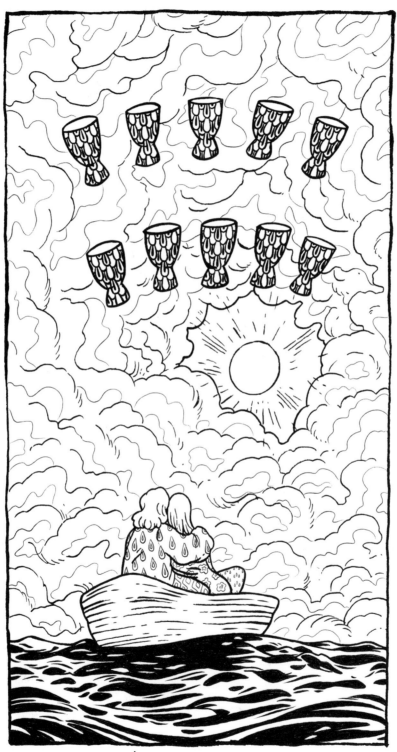

ten of cups

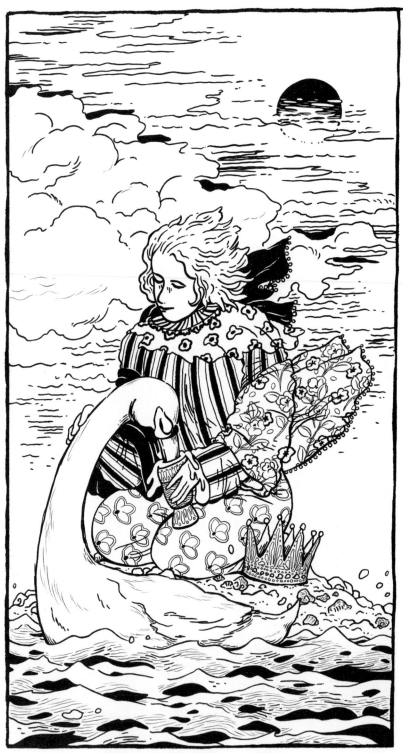

princess of cups

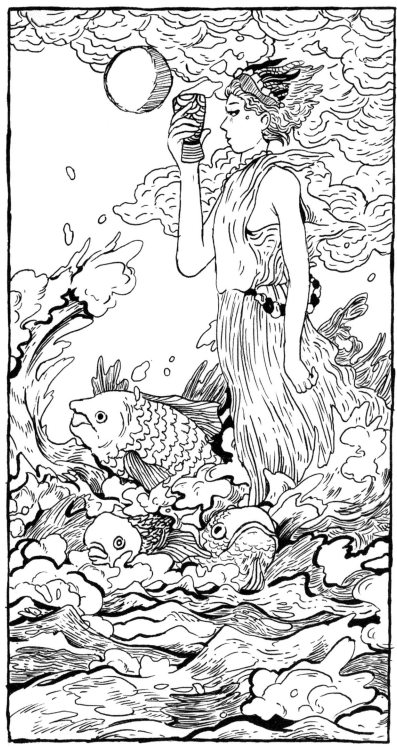

Prince of Cups

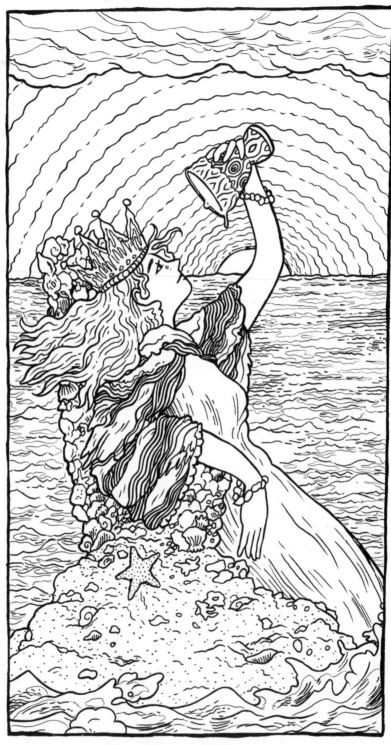

Queen of Cups

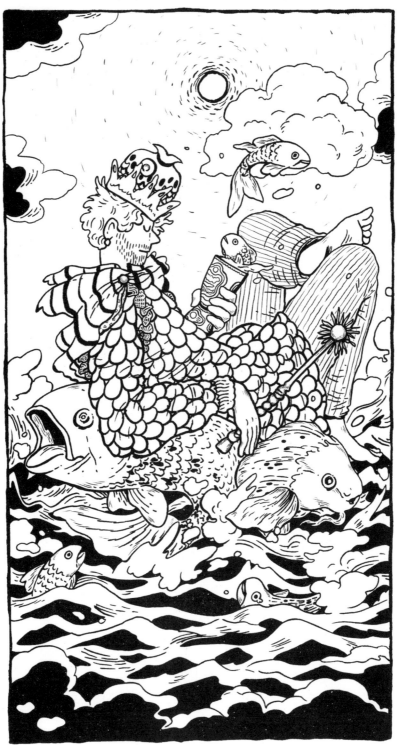

King of Cups

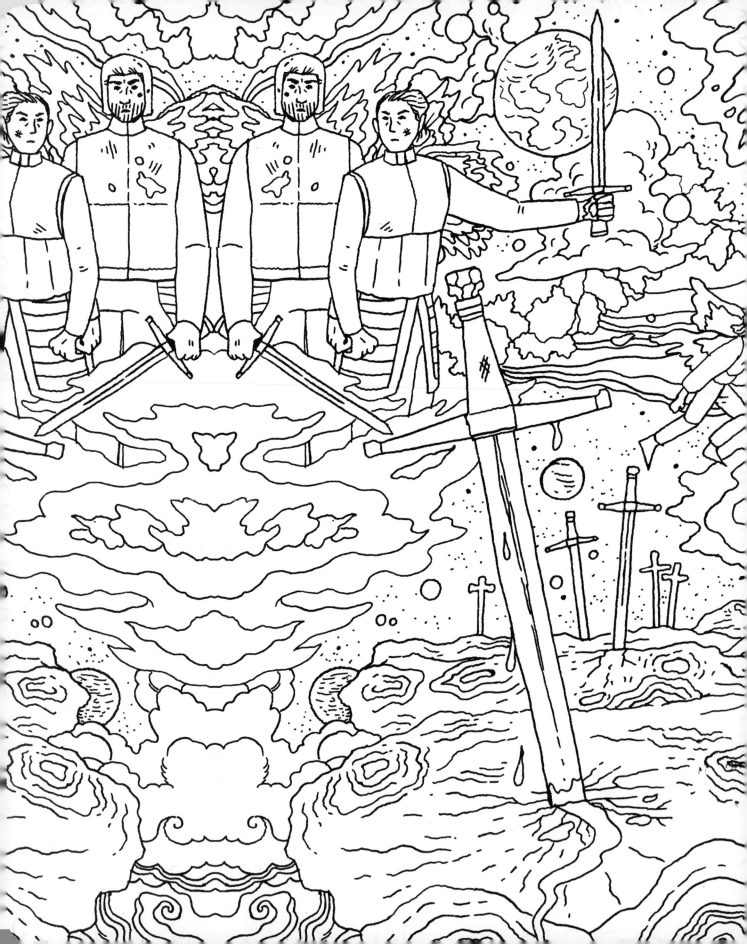

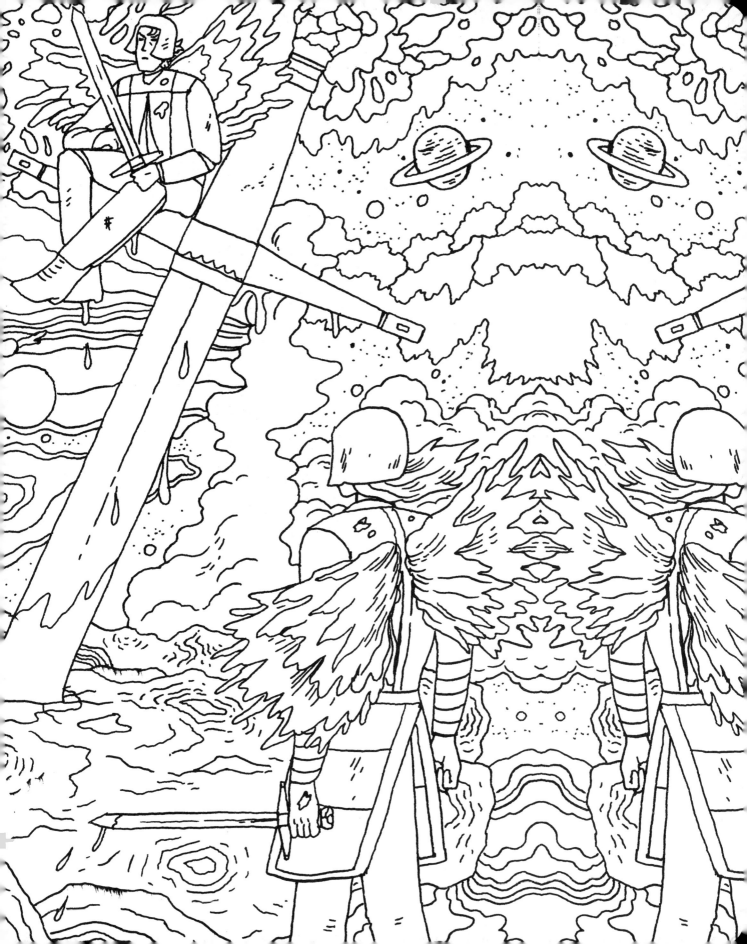

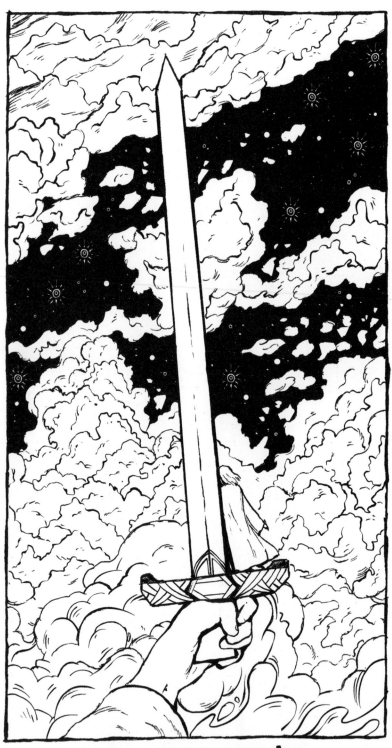

ace of swords

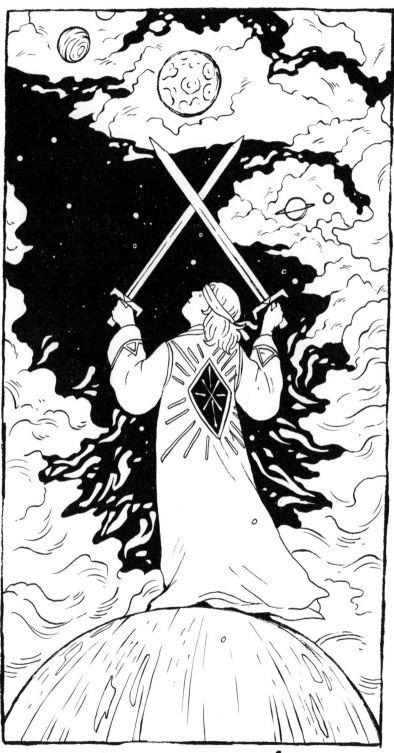

two of swords

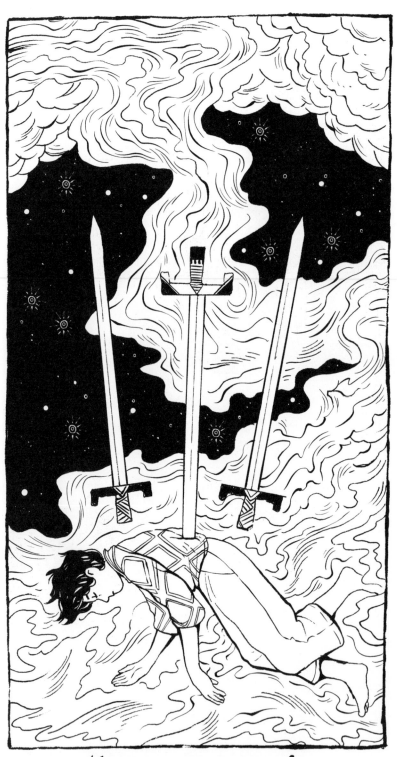

three of swords

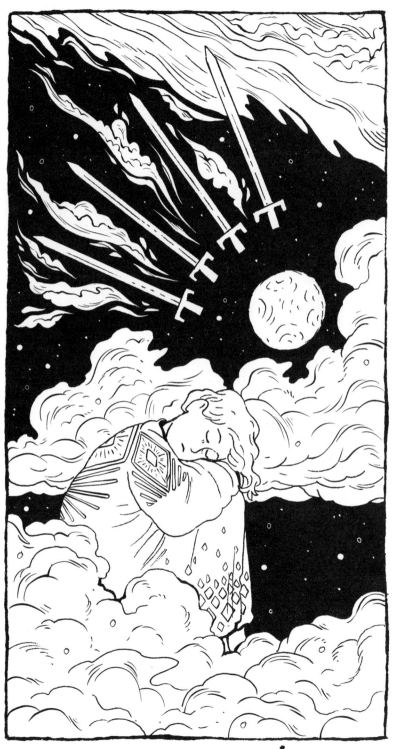

four of swords

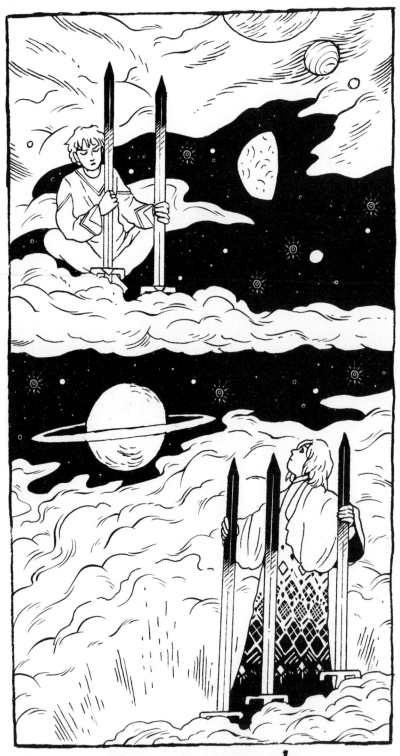

five of swords

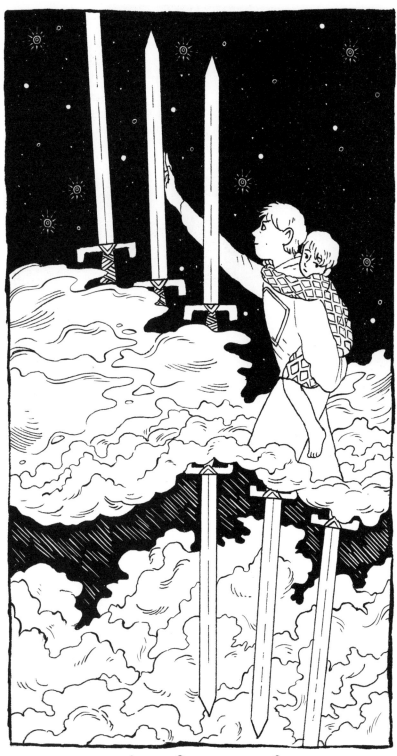

six of swords

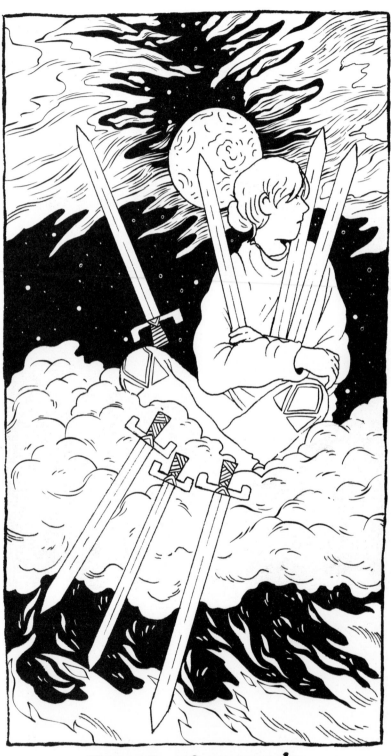

seven of swords

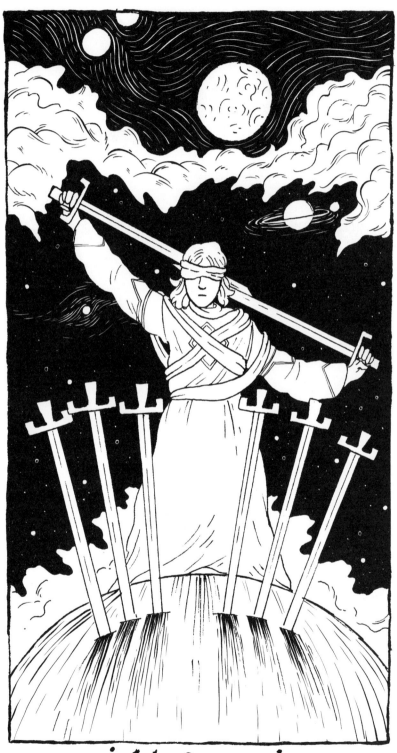

eight of swords

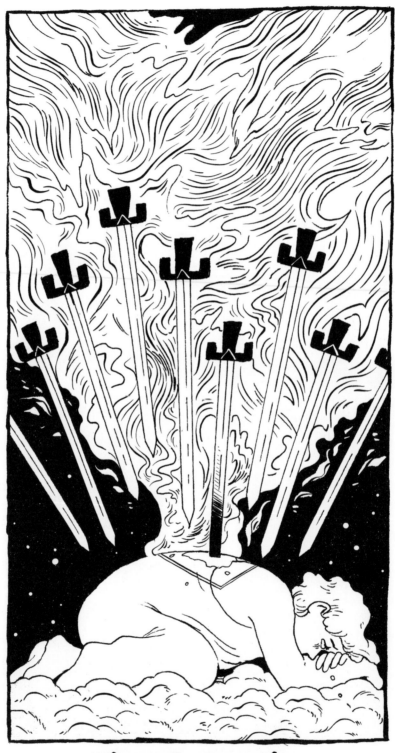

nine of swords

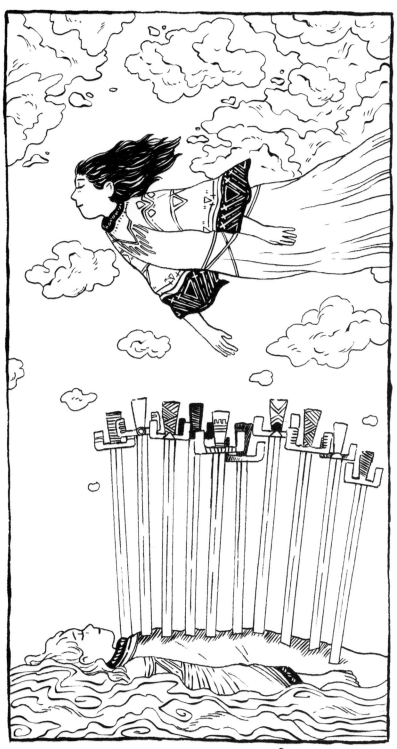

ten of swords

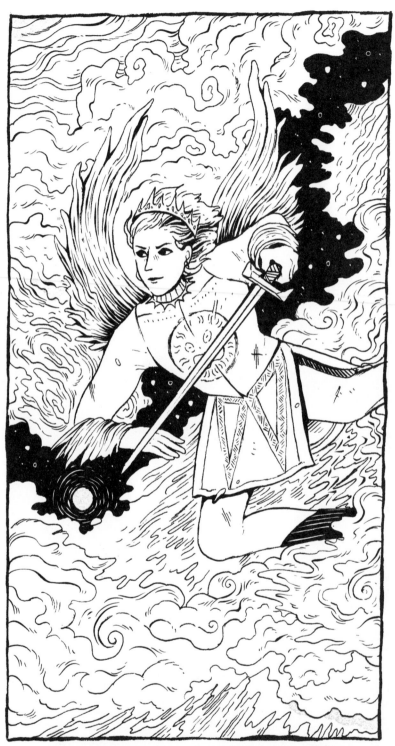

Princess of Swords

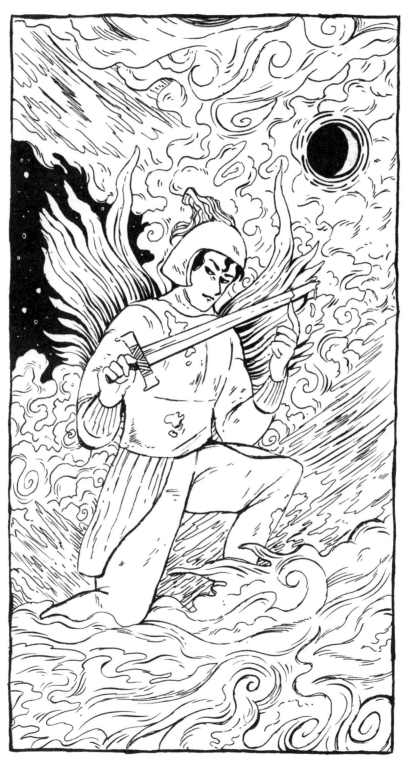

Prince of Swords

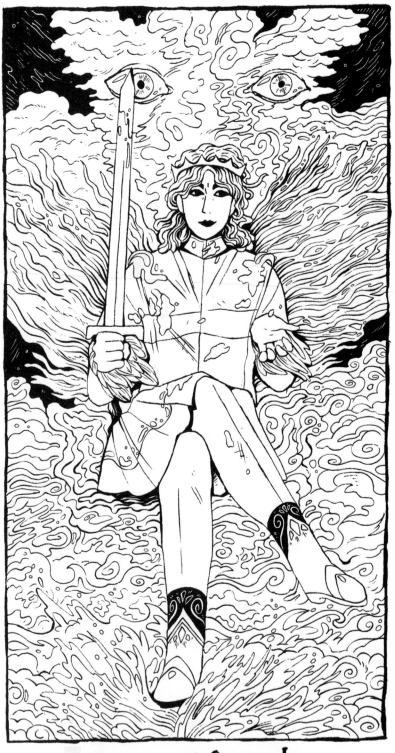

Queen of Swords

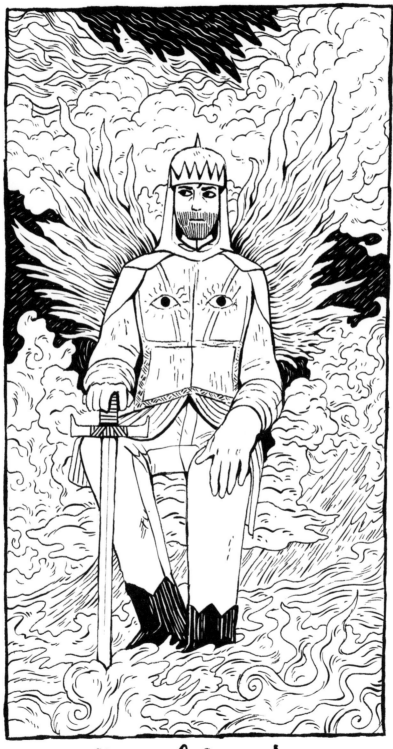

King of Swords

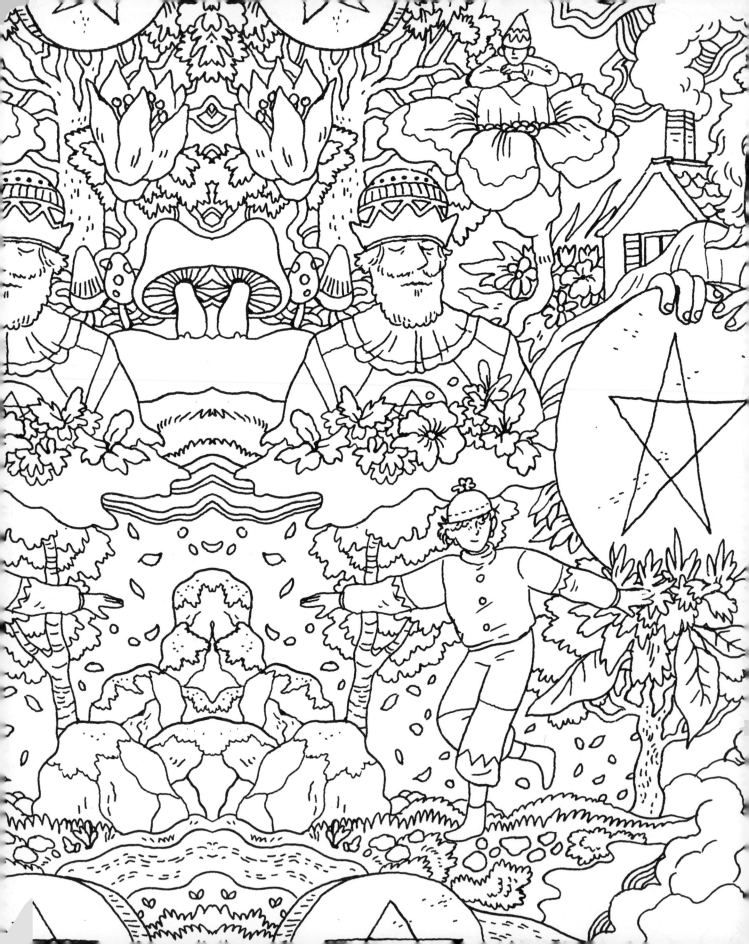

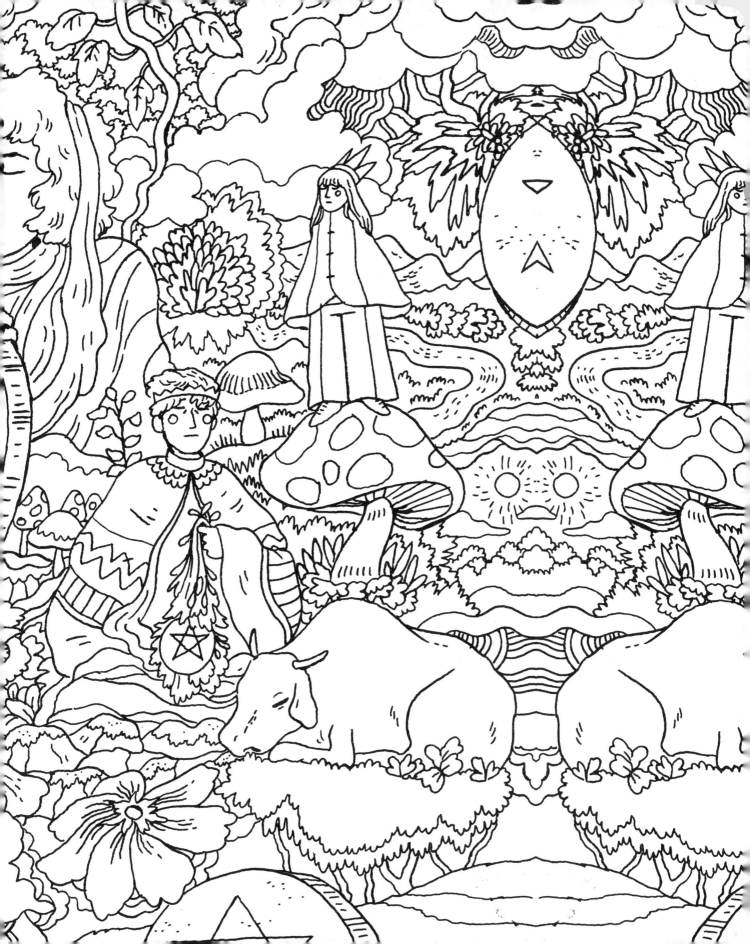

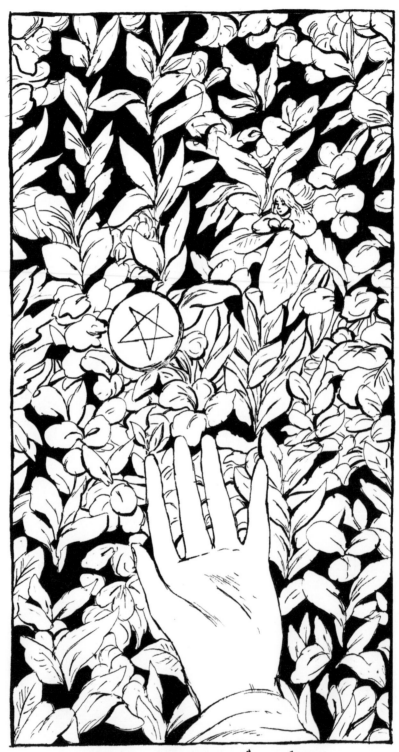

ace of pentacles

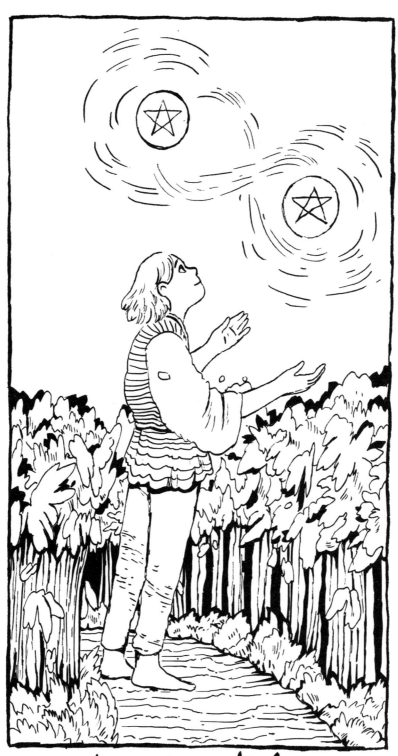

two of pentacles

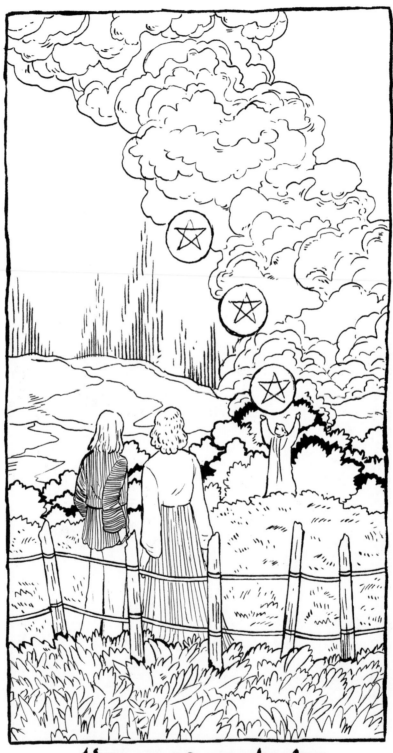

three of pentacles

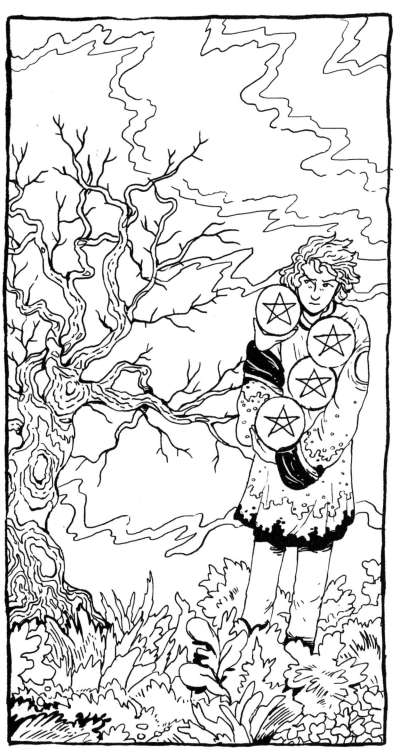

four of pentacles

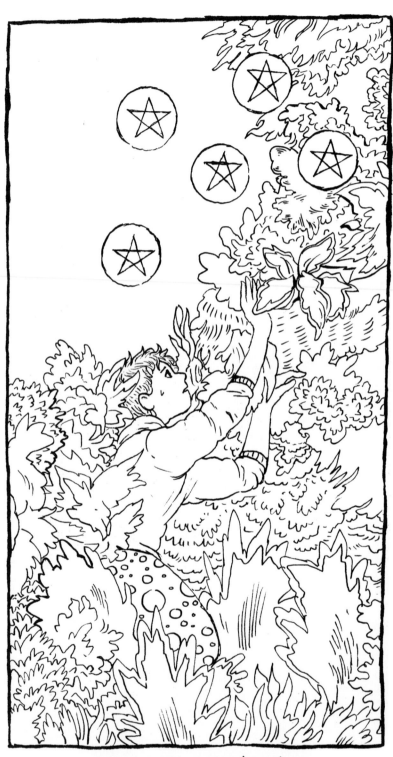

five of pentacles

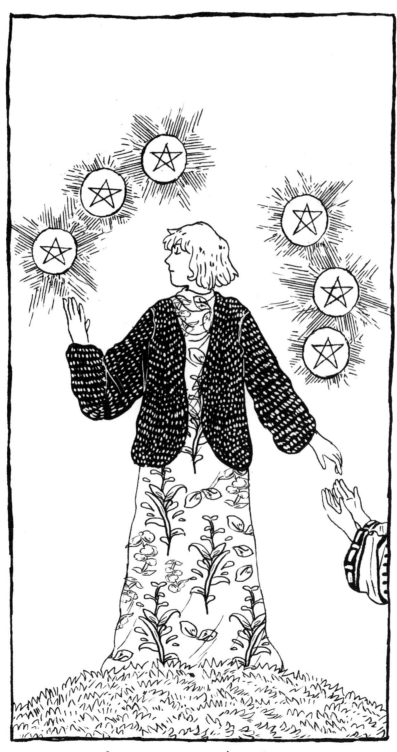

six of pentacles

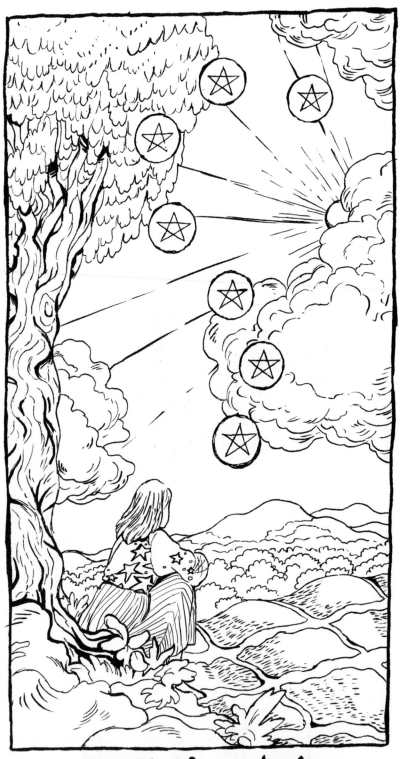

seven of pentacles

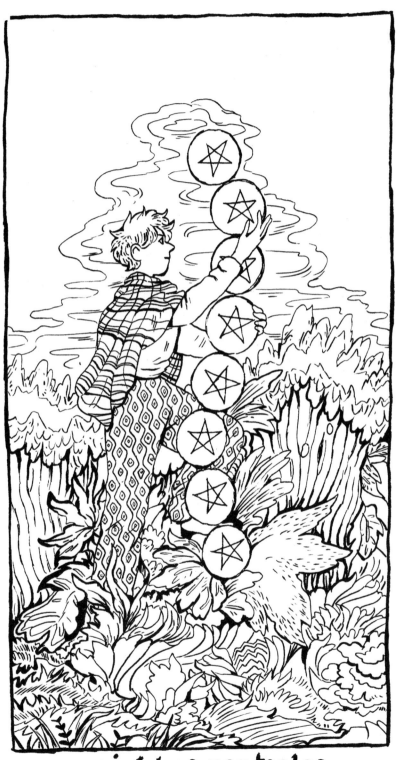

eight of pentacles

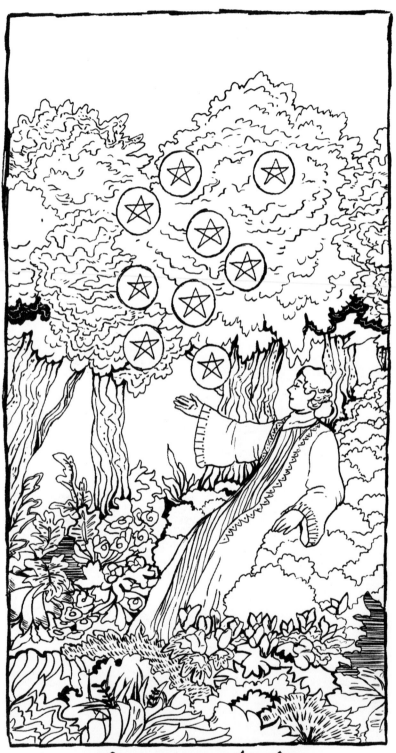

nine of pentacles

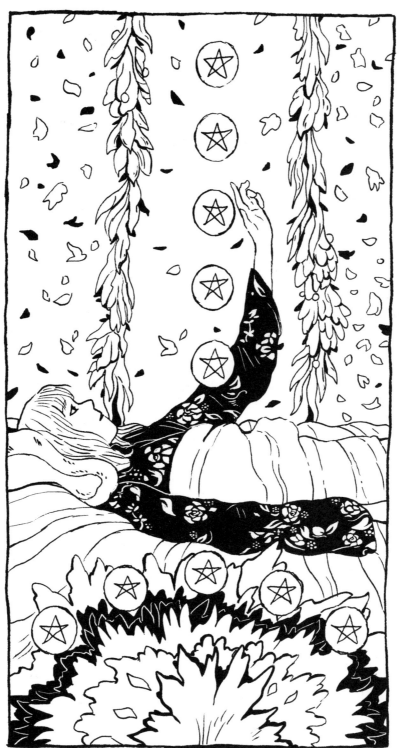

ten of pentacles

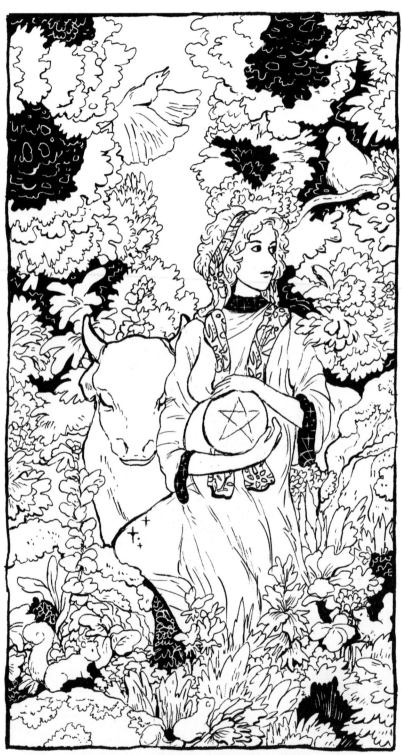

Princess of Pentacles

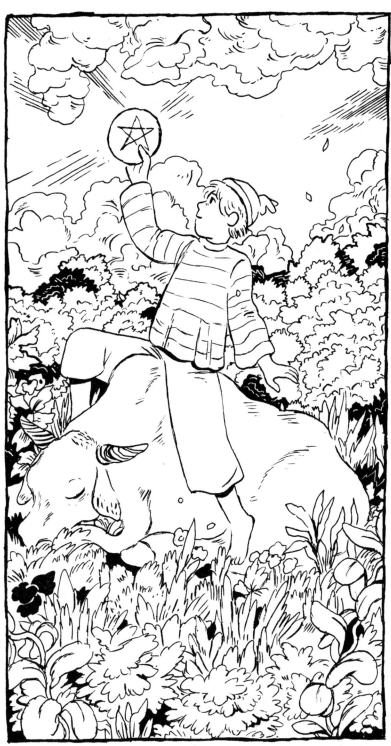

Prince of Pentacles

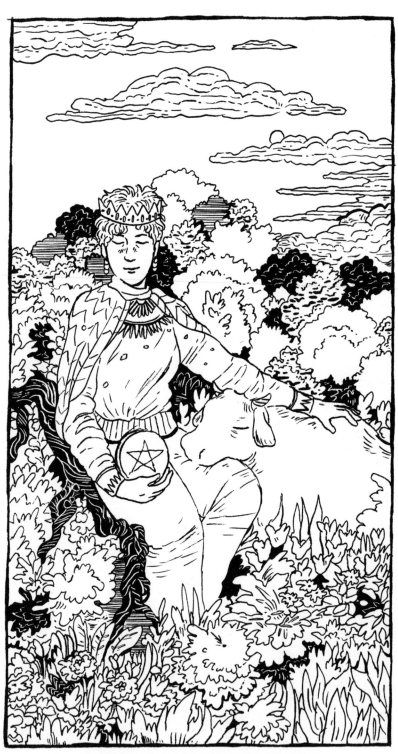

Queen of Pentacles

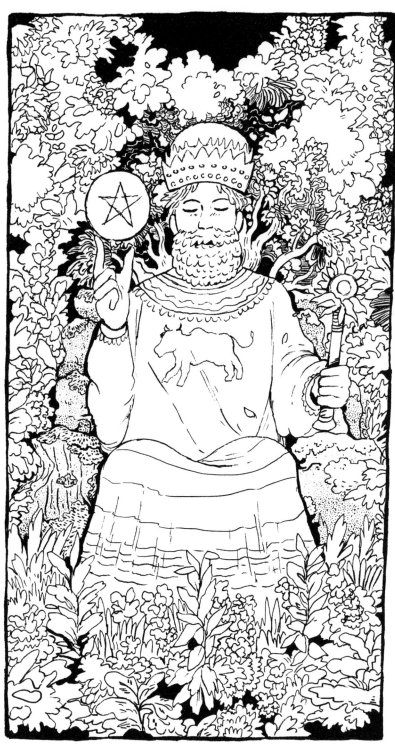

King of Pentacles

FURTHER READING

If you're interested in reading more about tarot, these books are a great place to start...

✧ *Seventy-Eight Degrees Of Wisdom* by Rachel Pollack

✧ *Tarot and the Archetypal Journey* by Sallie Nichols

✧ *Queering The Tarot* by Cassandra Snow

✧ *The Tarot: A Key To The Wisdom Of The Ages* by Paul Foster Case

✧ *Tarot Correspondences: Ancient Secrets For Everyday Readers* by T. Susan Chang

✧ *Secrets of the Waite-Smith Tarot* by Marcus Katz & Tala Goodwin